MICHAEL FREEMAN
THE PHOTOGRAPHER'S HANDBOOK

In his long and distinguished career, photographer and author **MICHAEL FREEMAN** has concentrated principally on documentary travel reportage, and has been published in dozens of major publications worldwide, including Time-Life, *GEO* and *Smithsonian* magazine, for whom he has shot dozens of feature stories across the globe over the course of a three-decade relationship. Much of his work has focused on Asia, beginning in the early days with Thailand, and expanding throughout Southeast Asia, including Cambodia, Japan and China. His most recent book of documentary reportage is *Tea Horse Road*, tracing the ancient trade route that began in the 7th century between southwest China and Tibet.

His numerous books teaching the craft of photography have sold over four million copies, and been translated into 27 languages. *The Photographer's Eye* is his bestselling volume, and has become the definitive work on photographic composition and design.

An Hachette UK Company
www.hachette.co.uk

First published in Great Britain
in 2017 by ILEX, a division of
Octopus Publishing Group Ltd
Carmelite House
50 Victoria Embankment
London, EC4Y 0DZ
www.octopusbooks.co.uk

Distributed in the US by
Hachette Book Group
1290 Avenue of the Americas
4th and 5th Floors
New York, NY 10104

Distributed in Canada by
Canadian Manda Group
664 Annette St.
Toronto, Ontario, Canada M6S 2C8

Publisher: Roly Allen
Publisher, Photography: Adam Juniper
Managing Specialist Editor: Frank Gallaugher
Art Director: Julie Weir
Design: Grade Design
Senior Production Manager: Peter Hunt

ISBN 978-1-78157-490-4

A CIP catalogue record for this book is available
from the British Library.

MICHAEL FREEMAN
THE PHOTOGRAPHER'S HANDBOOK

ilex

Contents

Introduction

There have been photography handbooks before (many), and I've been responsible for some of them. My first is now almost a historical document. So why bother with this one? The simple truth is that photography is changing faster now than at any time in its history. This handbook is a world away from the earliest I wrote because it has to deal with very different issues.

What's changing most is, perhaps surprisingly, not the technology but the very idea of what photography is about. We already had the digital revolution. That's now in the past, and what we have instead now is steady improvement in the technology. Capture becomes smarter and neater, and the possibilities of what you can then do with your images continue to increase. A bigger deal entirely is what all of us hope to get out of our photography and how to succeed at doing so. In an ocean of photographs, we all want to make interesting, personal images that somehow stand out among the millions—maybe trillions. It's a new world of photography in which everyone shoots.

For almost their entire history, photographers recorded places, things and events, and for much of the time it was enough simply to show what they looked like because the audience was never going to be able to experience these things for themselves. This was the purpose of the early picture magazines, and the "ƒ/8 and be there" (i.e., set your camera and show up) mentality ruled. As Lou Klein, the first art director who influenced me, said, it was all about being "in the right place at the right time." Of course, it wasn't. As a professional, he assumed that I was already capable of making a good picture out of any situation.

Now, there isn't that division between professionals and amateurs, and that's exactly why this handbook exists. It's about everything we all had to master, and that hasn't changed. What digital has done, however, is to enable photography for everyone—including those without a traditional camera—and to enable sharing with everyone else. There is no passive audience any more. For travel shooters, there are no viewers back home fascinated to see what they would never be able to for themselves. The audience for photos is now worldwide and they, too, take pictures, in the same places and at the same times. That simply means we have to try harder and become more skillful, not just at working the equipment but also at making images that are different, uniquely appealing, and then sharing them effectively. This handbook covers all of these bases, and its aim is to get you there.

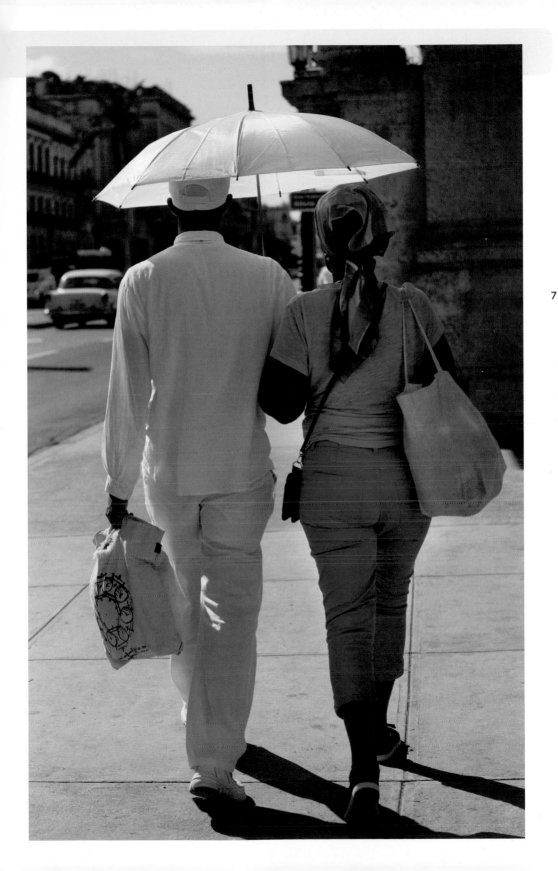

There have been photography handbooks before (many), and I've been responsible for some of them. My first is now almost a historical document... so why bother with this one? The simple truth is that photography is changing faster now than at any time in its history. This handbook is a world away from the earliest I wrote because it has to deal with very different issues.

What's changing most is, perhaps surprisingly, not the technology but the very idea of what photography is about. We already had the digital revolution. That's now in the past, and what we have instead now is steady improvement in the technology. Capture becomes smarter and neater, and the possibilities of what you can then do with your images continue to increase. A bigger deal entirely is what all of us hope to get out of our photography and how to succeed at doing so. In an ocean of photographs, we all want to make interesting, personal images that somehow stand out among the millions—maybe trillions. It's a new world of photography in which everyone shoots.

For almost its entire history, photographers recorded places, things and events, and for much of the time it was enough simply to show what they looked like because the audience was never going to be able to experience these things for themselves. This was the purpose of the early picture magazines, and the "$f/8$ and be there" (i.e., set your camera and show up) mentality ruled. As Lou Klein, the first art director who influenced me said, it was all about being "in the right place at the right time." Of course, it wasn't. As a professional, he assumed that I was already capable of making a good picture out of any situation.

Now, there isn't that division between professionals and amateurs, and that's exactly why this handbook exists. It's about

1

TECH

everything we all had to master, and that hasn't changed. What digital has done, however, is to enable photography for everyone—including those without a traditional camera—and to enable sharing with everyone else. There is no passive audience any more. For travel photographers, there are no viewers back home fascinated to see what they would never be able to for themselves. The audience for photography is now worldwide and they, too, take pictures, in the same places and at the same times. That simply means we have to try harder and become more skillful, not just at working the equipment but also at making images that are different, uniquely appealing, and then sharing them effectively. This handbook covers all of these bases, and its aim is to get you there.

A FEW THINGS YOU SHOULD KNOW

Mastering the tools of the trade is a basic necessity for any endeavor. Photographic tools are essential, and so is any photographer's skill with them. The question is, how much do they contribute to the final image?

In case this seems like a strange question, photography more than most creative activities has a complex relationship with equipment. Bright and shiny mechanical engineering attracts many people for its own sake, and unfortunately for photography, this tech love can take away from the passion for making images. Not everyone sees this as a problem, but if you have a hint of concern, the answer is a balanced view in which the tools are always in the service of the end result.

With that out of the way, operating a camera is, like driving a car, more about dealing with the interface than with the inner workings. No driver cleans a carburetor any more, and we're increasingly removed from the camera's workings. These are sealed engines, and we photographers mainly benefit from this as it allows us to concentrate on more essential matters like making great images. That said, there are some things worth knowing about our tools.

Probably the first thing to note is that the menu makes a modern camera look more complicated than it is. There's usually a huge choice of settings and other options, but it masks a functional simplicity that hasn't changed much in decades. The lens projects an image onto the sensor and can be focused to make this image, or parts of it,

sharp. Two moving parts interrupt the light path: an aperture diaphragm in the lens that opens or closes to let more or less light through, and a shutter that can be set slower or faster to the same end. As the aperture also controls depth of field and the shutter can freeze or blur motion, you can choose which combination of settings to use to get the right exposure. You can also choose to amplify the sensor's sensitivity to control the exposure, and a light meter inside the camera helps you decide what that exposure should be, meaning how bright or dark the photograph will be.

That's basically it. All else is refinement or an excess of choice, depending on how you see it. Menus are extensive because they can be and because they give camera manufacturers something to talk about, but realistically, most of the choices are intended to be set once by you and then left alone. Many of them are ways for you to personalize the camera's operation. The entire menu and instructions are worth going through at least once in detail, although it's unlikely you'll need to revisit most of it. Even if you don't bother or leave it until later, the default automatic settings will usually give you a perfectly good result as almost every function can be automated.

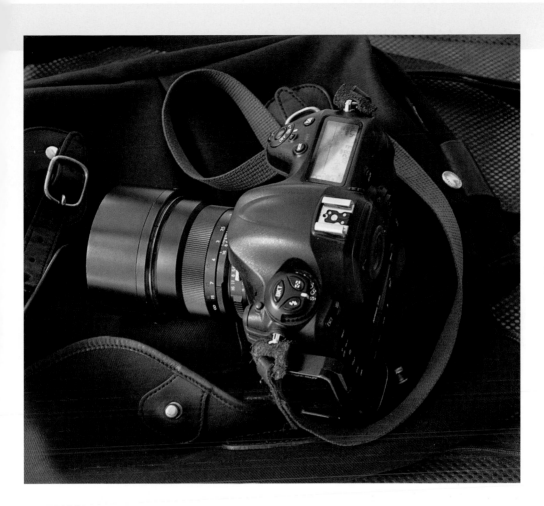

Above: Whatever the camera (this is mine), it's an
extension of your eye and hand, and if you're a
committed photographer you need to be completely
familiar and comfortable with it.

THE HEART OF THE MACHINE

Photography is very physical and the camera in your hands is the embodiment of that. It's a tool, a machine, a piece of engineering. The casing and controls are what we engage with and have opinions about (chunky, neat, ergonomic, elegant, etc.), but even so, modern cameras are increasingly defined by their sensors.

Previously, you could expect a camera to have a very long life; image improvements came from advances in film. Now, it's built around the sensor and the supporting software and firmware, all of which are continually being improved, so you'll at some point want to replace it. If not exactly disposable, modern cameras have a lifespan limited by technological advances.

If you think just about image quality —the amount of detail recorded, color faithfulness, the range from bright to dark—then the camera body is only as good as its sensor. This makes it a little difficult to judge between models, because not only is sensor technology complex, but camera manufacturers reveal as little as possible about it while at the same time always putting the best interpretation on its performance. Most opinions shared on the internet about camera-sensor performance are of little value, but at least one site, DxOMark, publishes objective comparisons.

How much you actually need to know about your sensor is a lot less than the full technological picture. The first thing that may affect your choice of camera is the sensor size and how many pixels it delivers. The pixel is the smallest unit of an image, and each one comes from a photosite on the sensor—in essence, a light cell covered with a small lens. The amount of detail you can record depends on both the size of the sensor and the number of pixels.

For image quality, the larger the sensor the better, which is why professional DSLRs are full-frame (24 x 36mm) and more expensive that the APS-C (16 x 24mm) format popular in mid-level cameras. It's also why there's a demand in studio, landscape, and architectural photography for the larger, bulkier, and much more expensive medium-format cameras and backs, which range from around 30 x 45mm to 40 x 54mm and have resolutions up to 100 MP.

That's not the end of the story, though. There's still a tradeoff when the sensor is being designed between packing in as many photosites as possible (higher resolution) and having larger photosites (better light gathering). High pixel density means more detail recorded, but larger pixels means a better range of tones from bright to dark and better ability to shoot in dark conditions. The range of tones from bright to dark is called the dynamic range, and it depends considerably on the signal-to-noise ratio and the noise floor. A low noise floor means more detail captured in dark conditions, and that comes with larger photosites.

In short, maximum resolution, if that's important to you, comes with less ability to shoot in low lighting, and some camera sensors are designed for that. Other camera models balance quite high resolution with good low-light performance. The priorities are for you to choose.

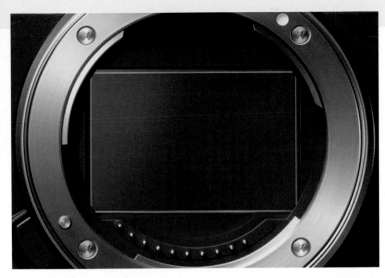

Left: The state-of-the-art, 42-megapixel full-frame (36mm x 24mm) sensor at the heart of the Sony Alpha 7rii.

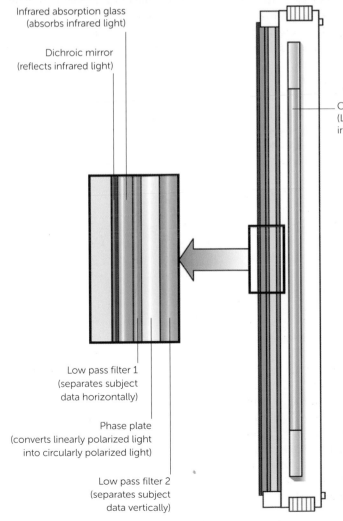

Infrared absorption glass
(absorbs infrared light)

Dichroic mirror
(reflects infrared light)

CMOS Sensor
(Light received as
individual RGB pixels)

Low pass filter 1
(separates subject
data horizontally)

Phase plate
(converts linearly polarized light
into circularly polarized light)

Low pass filter 2
(separates subject
data vertically)

Left: The photosite layer of an imaging sensor sits under a variety of filters, each of which serves a particular purpose. In some cases, there may be no low-pass filter at all, which increases image acuity, while risking moiré.

Whatever the size, resolution, and light-gathering ability, sensors capture more data than can be seen on a computer screen or in a print. Our eyes can distinguish between about 10 million different colors and tones, and most computer screens and JPEGs show 16.7 million—more than enough. The shorthand way of describing this level is 8-bit, which means eight digital bits to describe each pixel per channel (red, green, and blue).

A paper print shows less. A good digital camera, however, records in 12-bit or 14-bit, and as the table on page 16 shows, that's a massive increase. In the right conditions, that can mean up to four f/stops of extra image data, and that's useful when

processing the image down to 8-bit to recover more highlights and more shadow details. This is exactly what the camera's imaging processor does if you elect to save JPEGs or TIFFs. It aims for the best result and then throws the unused bit depth away. You can, however (and usually should), choose to save the Raw file when you set up the camera menu. Then you can use your computer's more powerful processor to get exactly the results you want rather than leaving it to the camera. You can also revisit and reprocess as many times as you like. This is the overwhelming argument for always shooting Raw. They're bigger files, but so what? Data storage is very cheap.

Below & opposite: From left to right, the sequence of processing the captured image into one with normal appearance, from de-mosaicing through white balance and gamma curve, as detailed opposite. All of this happens before you see and process the image.

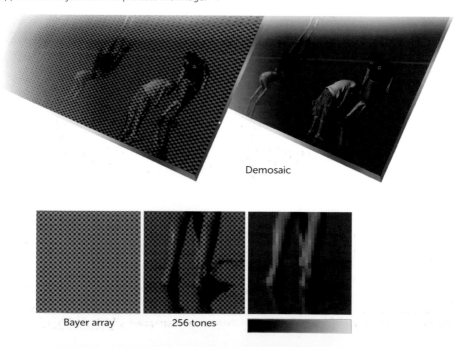

Demosaic

Bayer array 256 tones

The Raw Conversion Sequence

This is what happens when the captured image is turned into a viewable one, either in the camera or on your computer. Except with special software, you don't see these steps until the end:

1 **"Demosaicing"**—The blocky patchwork of colors from the color filter array at the front of the sensor is processed to resemble the originals in the scene. This is very intensive and, frankly, better tackled in a computer—one of the arguments for shooting Raw and processing it in Photoshop, Lightroom, Capture One, or other software. Software engineers put a lot of effort into getting this step right.

2 **White Balance**—The overall color appearance is adjusted according to the choice selected on the camera. The double number of green filters in the color filter array adds a green cast that needs to be removed. Your chosen white balance setting is kept as a tag that, if you save the Raw file for later processing, the software can use or ignore as you see fit.

3 **Apply Gamma Curve**—The sensor records light in proportion to the exposure, in a linear way. Our eyes do not see light linearly. They are much more complicated, employing a logarithmic response while scanning the scene rapidly so they sense a wider range of brightness. This original linear image looks much too dark to our eyes and, to appear normal, is given a strong adjustment curve known as a 2.2 gamma curve. This expands the darker pixel levels and squashes the brighter pixel levels.

4 **Tidying Up**—Various other jobs include applying some sharpening to take care of the slight softening caused by "demosaicing" and applying contrast and saturation adjustments.

At this point, you can make your own adjustments during processing (see pages 86–95), using a Raw-processing engine like Adobe's ACR, or other tools. You can then save the image as a TIFF, a JPEG, or a DNG (digital negative), but not in the original Raw format, which is proprietary to the camera manufacturer.

15

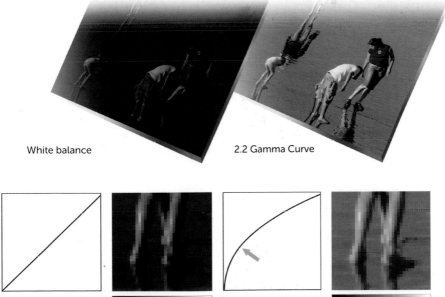

White balance

2.2 Gamma Curve

Linear-encoded original

Gamma correction applied

Shooting Raw

Image file formats are the ways in which the picture is coded and stored, and you have a choice. The original format direct from the sensor is called Raw and its coding is proprietary to each manufacturer. Raw contains more tonal and color information (measured in bit-depth) than can be displayed on a screen or in a print, and for that reason allows you wide processing choices (i.e., you can recover shadow and highlight details) when you convert this into one of the two normal formats for saving: JPEG or TIFF.

JPEGS are 8-bit, compressed in size with some small, usually unnoticeable loss of quality, and are the standard format for distributing across the Internet. TIFFs can be compressed without loss and are standard for archiving; they are either 8-bit or 16-bit (the latter for further image adjustment). If you choose JPEG or TIFF format in the camera's menu, the camera's processor will make the conversion automatically, but shooting and saving Raw, which most cameras allow, gives you the opportunity to take care over the processing yourself. This is the single most compelling reason for shooting Raw, unless sending the image is so urgent that you need a JPEG instantly.

	Bit-depth Per channel	Number of Colors/Tones
Human Vision	n/a	~ 10 million
8-bit JPEG	2^8	16.7 million
12-bit Camera Raw	2^{12}	68.7 billion
14-bit Camera Raw	2^{14}	4.4 trillion
16-bit TIFF	2^{16}	281 trillion

How Sensors Impact Image Quality

Number of pixels determines image resolution and level of detail captured

Larger sensors allow more pixels and **shallower depth of field**

Photosite grid pattern on the sensor can cause a **moiré** (interference) pattern if the grid coincides with a pattern in the scene (i.e., a distant row of railings)

Larger pixels collect more light, improving **dynamic range** and low-light performance

Raw files capture **more information** than the final viewable image

Color is **interpolated**, and so can be re-interpolated later

Color resolution is much **less** (a third) of the luminance resolution

Overexposed photosites record no data whatsoever, sometimes resulting in "**clipped highlights**" that are cut off from the natural flow of highlight details

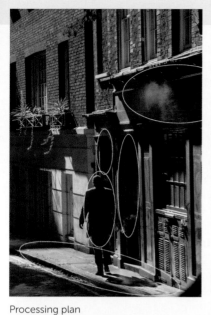

Processing plan

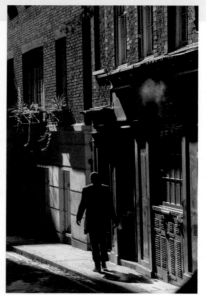

JPEG file processed

This page: The value of shooting Raw stands out with high dynamic range scenes. The ovals on the processing-plan screenshot (top left) show local adjustments. Applied to the Raw file on the left, they reach deeper into the dynamic range of this backlit shot than they do when applied to the JPEG above.

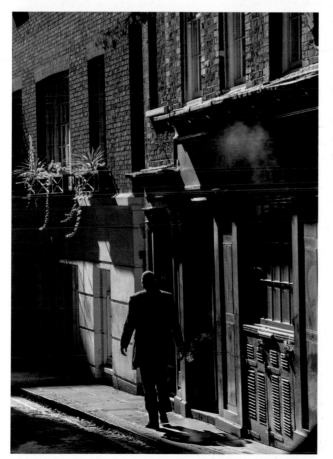

Raw file processed

AMP THE SENSITIVITY

One special advantage of modern sensors is that their light capture can be amplified in-camera without too much damage to image quality. ISO (International Organization for Standardization) is the successor to ASA (which was used for film) and is the measure of sensor sensitivity. The lowest number available on your camera— typically ISO 100 or ISO 200—is its base sensitivity and will give you the best image quality possible.

You can raise your ISO for a better response to light, and most people do this when light levels get low, such as after sunset or in deep shade. Doing this does not change the response of the sensor to the light striking it; instead, it amplifies the signal. There are consequences, however.

Modern cameras allow for ridiculously high amplifications so that you can shoot in conditions where even your eyes have difficulty seeing. In other words, it is possible to shoot in almost any lighting conditions. However, the penalty for

raising the ISO, as with any kind of signal amplification, is an increase in noise—the visual equivalent of an audio hiss. There are three basic kinds of noise: random, fixed-pattern, and banding. Random noise is the one most affected by raising the ISO, and it appears as a coarse speckling, more noticeable in smooth areas of the image. There are no hard and fast rules about how much noise an image should or shouldn't have. That depends on how large the image will be displayed as well as on what you personally deem acceptable.

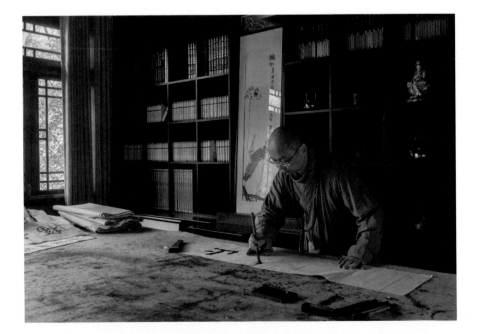

The Exposure Triangle

There are three camera settings that control brightness: aperture, shutter speed, and ISO. You select your combination of these three to get an exposure, hence the expression "exposure triangle." Two of them control how much light enters the camera to strike the sensor (aperture and shutter speed), while the third, the ISO setting, works differently in that it amplifies the signal. Raising one of these three settings means you need to lower one or both of the other two. There's always more choice with plenty of light, but in darker situations you will have to prioritize one setting and make compromises.

Unlike traditional film grain, noise has no redeeming qualities and just degrades the image, so the exposure triangle is in fact a lopsided one. There are good reasons for wanting to increase or decrease both aperture and shutter speed, but raising the ISO is always a negative, last-resort choice. This makes choosing the balance between the three settings interesting and skillful. Using the exposure triangle means knowing clearly what your priorities are for any shot—typically an ideal shutter speed, a certain depth of field, and overall image quality.

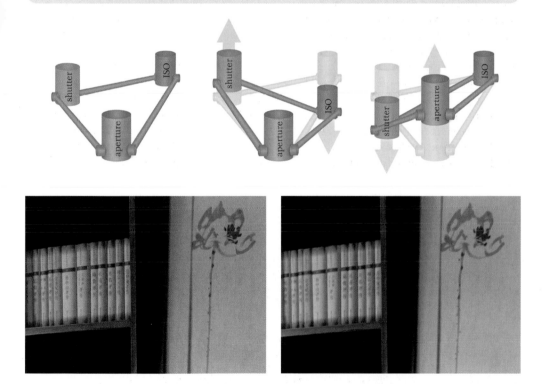

Left & above: A high-ISO setting brings noise, which interferes with detail, but allows faster shutter speeds. Here, in a temple in Hangzhou, China, the scene was shot at ISO 3200 (above left) to capture the movement, but then again, without the monk, at ISO 200 (above right). Combined as layers in Photoshop, they were composited manually with an eraser brush.

PERFECT EXPOSURE

With a choice of different metering methods—particularly including smart metering, which goes by different brand names but basically subdivides the scene into a mosaic of brightness then compares this pattern with a database of thousands of images—there should be nothing getting in the way of perfect exposure every time. Nothing, that is, except the crucial ingredient of what you personally want the final image to look like.

Many professionals bypass the uncertainty of confronting a new exposure situation by relying on their experience, and by comparing the new scene or setup with what they've done before. They also tend to stick to one exposure mode so that they're familiar with its shortcomings.

It's important to keep in mind that the pattern of brightness in a scene is independent of the actual subjects and what they mean. This simplifies things greatly, because in the end, all can be fit into 12 basic situations (see pages 22–25). These 12 are in three groups, defined by the dynamic range: just fitting the sensor's ability, low dynamic range, and high dynamic range.

A normally lit scene will just fit the dynamic range of your sensor, more or less—that's one group. If it's flat and obviously lacking in contrast, it will easily fit—that's group two. The third group, with most of the problems, is when the scene is so contrasty that it's out of range and your sensor isn't able to capture every tone from dark to bright.

There's an exposure (and processing) strategy for each group and it relies on identifying the important tone in the scene—the key tone. What part of the subject is most important to you and how bright you want it to be? It could be a face, for example, but then is the skin color pale or dark? In the case of a building, is the sunlit or the shadowed part more important for you to capture? These decisions are what make photography personal, so make your own shooting experience the driver for setting exposure.

Key Tones

The fast track to successful exposure is very much based on experience and judgment and is simply this: Learn to identify the most important tone in the picture you're about to take, and to decide how bright you want it. This key tone may well coincide with the obvious subject (such as the skin tone in a portrait), but it may just be one part of a subject (such as the sliver of light striking an edge-lit object). And of course, the key tone does not have to be an average midtone. Just think of the difference in a portrait between dark black skin and pale Caucasian; one needs to be at least one stop darker than average, the other a little lighter.

Group 1: Just Fits—The Ideal Scenario

This lighting situation is in bright yet not harsh sunlight, the dynamic range of the scene more or less fits that of the sensor and there should be no problems. It does, however, mean deciding whether you want the overall exposure to be bright (high key) or dark (low key). There are three kinds of situations for this group (see images on page 22).

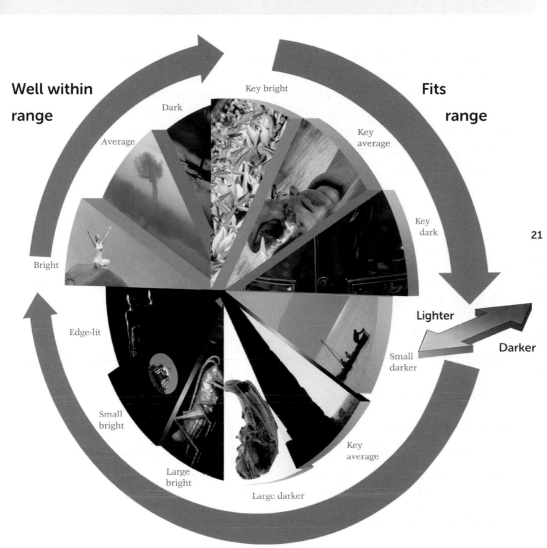

Well within range

Fits range

Key bright

Dark

Key average

Average

Key dark

Bright

Lighter

Darker

Edge-lit

Small darker

Small bright

Key average

Large bright

Large darker

Out of range

Group 2: Low Dynamic Range—Easily Fits, Expands Your Choice

Low dynamic range so easily fits the capability of any camera sensor that it can even tolerate exposure mistakes. More than that, you can (and should) choose how bright or dark overall you want to look. It can be average or dark or bright and still look perfectly fine. There are three kinds of situations for this group (see images on page 23).

Group 3: High Dynamic Range—Out of Range, Time to Prioritize

When the range of brightness in the scene you're shooting is greater than the camera's sensor can record, this is when something has to give and you need to take special care in thinking about the exposure. The camera won't be able to capture everything, so you'll need to prioritize something in the scene. There are six different scenarios for this group and each calls for a different strategy (see images on pages 24–25).

Just Fits (Average Dynamic Range)

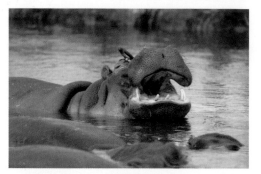

Average

Despite the dark-skinned hippo and water reflecting sky, the overcast light keeps the scene within range.

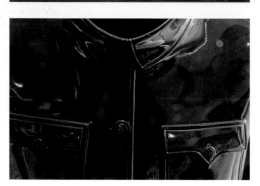

Overall Bright

The plumage of the massed pelicans needs to be kept close to white so the exposure needs to be about 1 stop brighter than the reading. (Even matrix metering is unlikely to predict such an overall brightness.)

Overall Dark

Again, even matrix metering will not predict that this black-glazed ceramic artwork should be darker by about 1 to 1.5 stops.

Easily Fits (Low Dynamic Range)

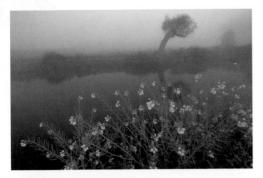

Average

This could have been brighter, but that was a personal choice. I wanted to keep the feeling of mist at dawn. I also resisted any temptation to close up black and white points.

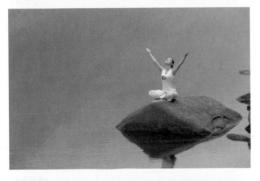

Overall Bright

Verging on high key, this was a similarly misty scene in which the subject called for a brighter, lighter mood, hence an exposure increase of 2/3 stop.

Overall Dark

I achieved a mood change to low key (a personal choice) through underexposing by 1 stop.

Out of Range (High Dynamic Range)

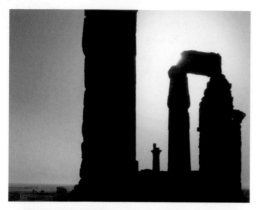

High Contrast Overall

No one tone is more important than another, so the question is: What are you prepared to lose? An average exposure is likely to lose highlight and shadow information, and most people would prefer to sacrifice shadows in order to save highlights from blowing out to unrecoverable white. That suggests a slight (1/2 stop to 1 stop) reduction of exposure. If you're shooting in autoexposure, that would mean using the exposure compensation.

Large Bright Subject, Dark Background

There's no doubt here that the key tone and subject are the lit, gilded bank sign, and the exposure should be for this alone. Matrix metering ought to be able to get that right, but center-weighted metering with the 12mm circle placed over the subject to achieve midtones would be certain.

Small Bright Subject, Dark background

Trickier than a large bright subject, measuring the small bright area alone suggests spot metering, which takes time and can be fiddly. Doing this with an off-centered subject involves taking the spot-meter reading aiming directly at it, then half pressing the shutter release and the Autoexposure Lock while you move back to the original framing. Or, you could use matrix metering and compensate by experience for what you've learned that this exposure mode is likely to do. (With my camera, I judge a tendency to overexpose so I lower the exposure by 1 stop.)

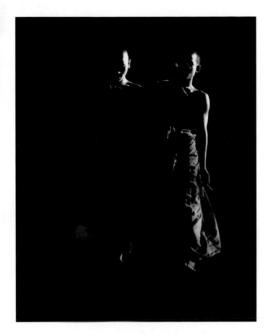

Edge-lit Subject

This is arguably the trickiest of all exposure situations to nail accurately, with light from a single source behind and yet out of view striking a glancing blow on the main subject. While the subject here is the two Burmese monks, the key tone is not the shadowed parts, but the edge of light. There are usually two ways to go with this kind of scene: Either keep the edge lighting within range and unclipped for a basically low-key effect or open up so that it glows and we see more of the darker areas. That's a personal choice, and here the first choice was taken. There are no standard, perfect solutions. Mine is to stick with matrix metering but know from experience of using it all the time where its failings are and compensate accordingly up or down (but rarely more than 1.5 stops, and usually not that much).

Large Dark Subject, Bright Background

Here, it very much depends on whether you want the subject averagely exposed (measure it alone and let the background go over) or as a silhouette (the background becomes your key tone and you need expose it a little brighter than average but without highlight clipping). In a studio setting like this, an incident light reading with a handheld meter is most practical.

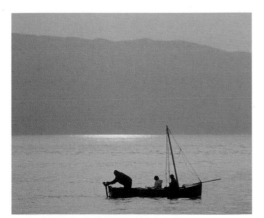

Small Dark Subject, Bright Background

The same basic decision applies in this situation as with a large dark subject, but here it's more likely that the bright background is the key tone, in which case you probably want it to appear brighter than average (possibly 2 stops brighter in a case like this), but definitely not clipped by overexposure.

COLOR BALANCE: IT'S PERSONAL

Photography depends on technology, so the idea of accuracy has seeped through into most areas of camerawork, including color balance, but that doesn't mean it's compulsory. In many if not most situations, the overall color of a scene is up to what you want it to be.

Color balance means shifting the entire range so that there's no sense of an overall coloring, so that whatever we think should be neutral gray appears as just that. Our vision system is very sensitive to neutrality, and the camera offers a choice at the time of shooting as a range of presets (i.e., Sunlight, Shade, Incandescent, etc.), including an automatic setting that does its best to find the neutrals in a scene and adjust the balance to suit. On some cameras, there's the extra choice of measuring the color of any white surface and keeping that neutral. However, if you shoot Raw, none of this matters, as these color-balance settings are separate from the actual image capture and you can adjust them all over again when you process.

If you need absolute objective accuracy, as you would if you were copying a painting, there are ways of measuring and setting the color balance according to industry standards. Typically, this involves using a color target like the X-Rite ColorChecker and then opening it in software such as Adobe's DNG Profile Editor. The software creates a camera profile that you can then apply to any image that you shoot in the same lighting.

Most of the time, however, we don't need anything like this accuracy, partly because our own assessment of neutrality is pretty good, but mainly because, when it comes right down to it, photographs are judged simply by looking. One classic case is Golden Light at the beginning or end of the day. When we see it, the color doesn't seem so orange because our eyes have had time to adapt. On the other hand, when we look at a photograph, we're conditioned to expect some golden glow. Nevertheless, you might legitimately decide to have it look anywhere between very orange and cool white.

Left: An early morning shot into the sun with the camera's white balance set to Auto delivers a more-or-less neutral result at 5500K.

Left: It would also be acceptable to have a colder-looking result by processing at 4500K.

Left: Or you could process for a warmer-looking result consistent with a low sun at 6550K.

CAMERAS

Not all cameras are created equal, and indeed, sometimes it feels like there is an overwhelming number of cameras on the market, so understanding the underlying technology can often help you make important purchasing decisions.

DSLRs

There's a reason why chunky, traditional, single-lens-reflex cameras remain the serious workhorse machine used by most professionals. They're efficient, relatively simple to use and, since the first Exacta in 1936, have delivered one incontestable virtue: You see through the viewfinder exactly what you're going to shoot. A mirror and a pentaprism (optical speak for the glass prism that presents the image right-side up for your eye) let you look straight through the lens itself. No other system does this, and if you're into engineering design, only this will do. The superstructure and the mirror flip-up mechanism make DSLRs heavier, bulkier, and noisier, but professionals who use them tend not to be bothered by these minor inconveniences.

The original film SLRs had another considerable advantage: They could be used with lenses of any focal length, however wide or long, and still give the exact view (which a viewfinder camera could not), and so they made long telephotos possible. This advantage no longer holds for DSLRs, but if you like to see exactly what you're shooting through clear glass and air, without an electronic interface, they're still unbeatable.

Right: A typical high-performance DX-format DSLR aimed at the top of the enthusiast market.

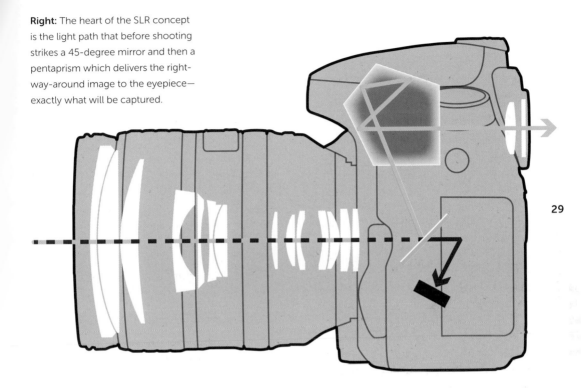

Right: The heart of the SLR concept is the light path that before shooting strikes a 45-degree mirror and then a pentaprism which delivers the right-way-around image to the eyepiece—exactly what will be captured.

Of course, there's no such thing as a free lunch. As shown above, the mirror box assembly requires a number of pieces to be all properly aligned and calibrated to each other, and this therefore introduces a number of points of potential failure. One such point of failure is the autofocus sensor, or more particularly, how the autofocus sensor interacts with the lens elements to achieve critical focus. Fortunately, a popular feature on current cameras addresses this issue—it's usually called "AF Fine-Tuning," and it allows you to calibrate each individual lens for your particular camera, by manually dialing in a positive or negative amount of compensation, depending on whether your lens was front- or back-focusing, respectively.

Mirrorless Cameras

Compared with DSLRs, mirrorless cameras are a relatively new camera format. These cameras lack the reflex mirror (and therefore the optical viewfinders) of a DSLR, allowing for a much smaller camera body. Instead of an optical viewfinder, users compose images either through an electronic viewfinder or via an LCD screen—some models only have the latter—making them closer in this respect to compact or bridge cameras. Unlike compact and bridge cameras however, mirrorless cameras have sensors close in size or as large as the majority of DSLRs, therefore enjoying all the advantages in image quality this brings.

The aim of these types of mirrorless cameras is to offer DSLR-style image quality, combined with the versatility of interchangeable lenses in a smaller, lighter, and less conspicuous package. While in many respects these cameras live up to that promise, they tend to be less capable when photographing fast-moving subjects. This is due to the different focusing system employed by DSLRs compared with almost all other types of camera—phase-detect autofocus, as described on the previous page, versus contrast-detect autofocus typically used in mirrorless cameras. Contrast-detect, as you may have guessed, requires an area of high-contrast to focus on. This results in extremely accurate

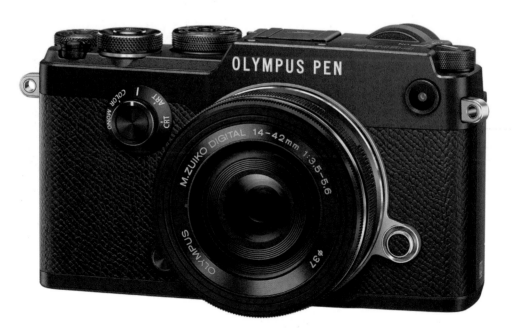

Above: Some mirrorless cameras emphasize both small-size and style, such as this retro-styled Olympus Digital Pen.

autofocus, as it does not have the calibration issues described previously that DSLRs sometimes suffer from. But for fast-moving subjects, it can be sometimes be best to decouple the autofocus from the shutter-release button, such that you can focus first, in anticipation of where your subject is going to be, and then fire the shutter once your subject is in frame.

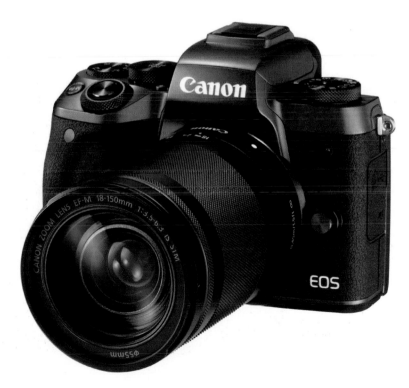

Above: Other mirrorless cameras adopt a more traditional DSLR styling, as with this Canon M5. It still benefits from size reduction by having the mirrorbox removed, and the viewfinder replaced with an electronic one.

Medium-format Cameras

The old-fashioned advantages of medium-format and large-format film—namely more detail from higher resolution, larger image files—continue with digital. Most come in the form of a detachable digital back that can be added to several camera systems, including PhaseOne, Hasselblad, Horseman, Alpa, and Sinar. The complexity of camera sensors, particularly large ones, means that there are only a few manufacturers of these backs—PhaseOne, Hasselblad and Mamiya Leaf—and prices are high. Relative to DSLRs and mirrorless, the price per pixel is also higher. Sensor sizes are currently typically between 50MP and 100MP, and the upper limits have risen over the last few years roughly in line with the increase in DSLR and Mirrorless sensor size. Leica claims medium-format status for their Leica S model, but at 37.5 MP this may be stretching the definition. A newer development, more in the tradition of medium-format film cameras, is a larger body with a built-in sensor, as in the Pentax 645Z.

There's no doubt that it's good to have a large image file for a valued photograph; you can then use it for larger displays—such as an imposing gallery print—but you should also weigh the pros and cons. Usually, the deciding factor is the maximum size of the image, onscreen or printed, that you anticipate a need for. The largest a magazine photographer would normally need would be enough for a double-page spread, typically 18 inches/46 cm by 12 inches/30 cm, and a 20 MP file would be sufficient. If you were shooting an advertising campaign to go on 48-sheet billboards (240 inches/6m by 120 inches/2m), a medium format camera would give you noticeably better image quality, although the counterargument is that billboards are usually viewed from a distance, not close-up.

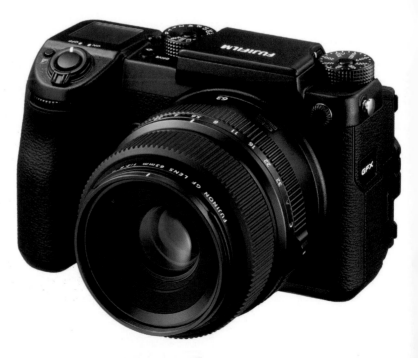

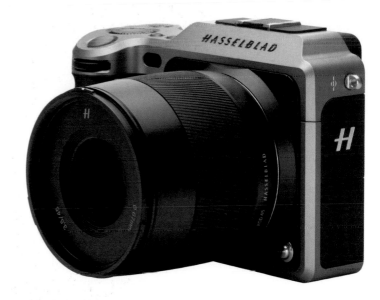

Left: The Pentax 645Z maintains the traditional mirrorbox assembly (though much larger than the one used on most DSLRs, as the sensor is much larger).

Opposite & right: These two cameras have the same size sensor as the Pentax shown above, but take the mirrorless approach of removing the mirrorbox and autofocusing directly off the sensor, and adding an electronic, rather than optical, viewfinder.

Fixed-lens Cameras

Point-and-shoot cameras:
These are small in size, typically have limited manual controls, and feature autofocus zoom lenses. Such cameras, often referred to as "compact cameras," are very simple to operate and are designed for people who primarily want a quick-and-easy visual record of vacations, birthdays, weddings, and similar events. In bright daylight conditions, point-and-shoot cameras can provide good quality images that look sharp at up to 8 × 10 inches.

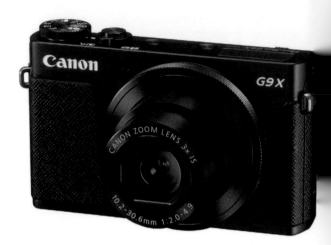

TECH | CAMERAS

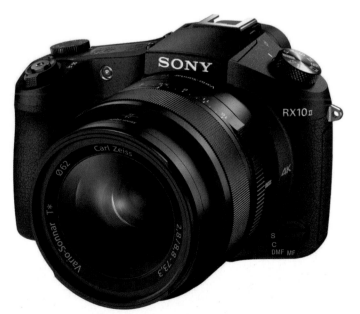

Bridge or superzoom cameras:
So-called because they "bridge" the gap between compact point-and-shoot cameras and digital SLRs, bridge cameras tend to be larger and have a richer photographic feature set compared to compacts. Most offer manual controls, an incredible range of focal lengths (from wide-angle to super telephoto). In addition, unlike most point-and-shoot cameras which utilize a rear LCD screen for composing images, bridge cameras also have an electronic viewfinder (EVF) through which photos can be composed. This is an advantage in bright conditions when it can be difficult to see an LCD screen.

Large-sensor compacts:
As a broad category, large-sensor compact cameras are the most recent type of fixed-lens cameras. Aimed at experienced enthusiasts, such cameras are often bought as portable backups to bulky professional equipment. These cameras offer full manual control, big imaging sensors (the same size or near to most digital SLRs) and high-quality lenses. However, the tradeoff is usually that the lens cannot zoom—it's the only way to put a large sensor in such a small body. Instead, it's typically locked at a moderate wide angle.

Computational Cameras

More and more phone cameras are incorporating a second, parallel camera to achieve effects impossible with a single lens/sensor. You can create 3D images, refocus the image after capture, blur the background to mimic a shallow depth of field, take photos in darker situations than would normally be allowed—all of which are made possible by the phone's processor, which is significantly more powerful than the typical processors in even high-end cameras.

Film Cameras

From a technological point of view, the biggest event in the history of photography was the changeover from film to digital, but the jury is still out on its effect on photographs. More to the point, there's a revival going on, and in the huge world of photography there's a sizeable place for people who want to shoot film. Some of them have simply never given up while even more are discovering the craftsmanship, simplicity, and mechanical appeal of working with the photography's original medium. From a digital perspective, film cameras are empty vessels, and it's all about the physical engineering.

35mm Cameras:

The first of these, like the Leica, were designed to make use of the newly available "sprocketed" motion picture film stock and had a separate viewfinder to give an approximate view of what was being framed. Focus uses parallax to bring two images in the focusing area together when the lens-focusing ring is turned. Such compact cameras revolutionized handheld photography. The next revolution was the single-lens-reflex camera, or SLR, which gave the exact view through the lens, by means of a flip-up mirror and a pentaprism that delivered a correctly oriented image through the eye-level viewfinder.

120 Roll-Film Cameras:

With a film width of 60mm (and variable length depending on the camera design), this medium format allows much higher resolution than 35mm. In the days when magazine- and book-printing processes were cruder than now, the extra film size helped guarantee image quality. Twin-lens-reflex cameras like the Rolleiflex were an early classic, using a matched second lens to view and focus. The cameras were designed to be held at waist level; you look down to the viewing screen where the image is reversed. The iconic Hasselblad brought the flip-up mirror from SLRs to medium format, and the Pentax 6x7 brought right-side-up pentaprism viewing; it was basically an enlarged version of a 35mm SLR. Film formats vary from 6x6cm through 4.5x6cm, 6x7cm, and 6x9cm on up to special panoramic cameras.

Sheet-Film Cameras:

Slow to use but the workhorses of studio, architectural, and serious landscape photography, a variety of camera models used film cut into sheets and pre-loaded into holders with dark slides that had to be pulled out for the exposure and then returned. Field cameras like the Deardorff were usually made of wood and foldable for portability. Technical cameras like the Linhof were all metal but functioned similarly and could be handheld in a pinch. The final development was the monorail studio camera, like the Sinar, which could be configured many ways but featured a front standard for the lens and a rear standard for the viewing screen and film which slid along a metal bar fixed to the tripod. The two most common film formats were 4x5-inch and 8x10-inch.

SHUTTER SPEED FOR CAPTURING MOMENTS

There are three core camera-and-lens systems that control image capture and therefore exposure: shutter speed, aperture, and ISO setting.

Shutter and aperture are mechanisms, while the ISO setting entails electronic amplification. Each has specific effects on the image: shutter speed affects how movement is captured, aperture affects depth of field, and increasing the ISO has a negative effect on image quality while increasing the ability to make a capture in low light. Basic camera operation means mastering these three systems.

In the exposure triangle of shutter speed, aperture, and ISO, there is always a tradeoff.

In the case of shutter speed, a really fast speed may come at the price of unwanted image noise or of shallow depth of field. There are, in fact, two parts to the capture of fast moments. One is the pure speed at which things happen and subjects are traveling. The other is how quickly the events come upon you and whether you're prepared for them; fast moments need the kind of quick response and dexterity that we can all understand, even if we have difficulty achieving it.

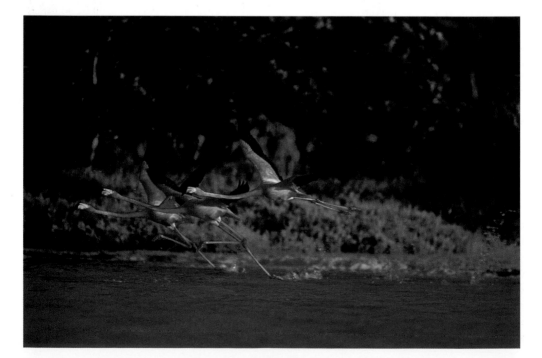

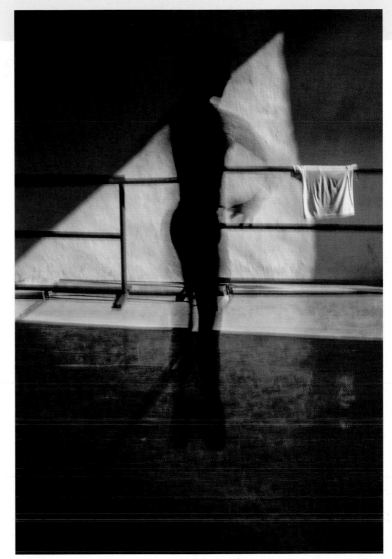

Opposite: Flamingos taking flight at Los Lagartos, Mexico—a moment that clearly calls for freezing with a high shutter speed of 1/500 second.

Top: The opposite approach to capturing movement is to blur it with a slow shutter speed (1/10 second) to create both ambiguity and ghosting, here for a ballet dance in Havana.

For the speed of what's happening, the prime matter is the shutter speed. Is it fast enough? The standard approach to choosing the shutter speed involves matching it to the speed of the movement you're trying to capture. The classic case is a moment that happens quickly, in the blink of an eye, demanding fast response and equally fast shutter speeds. By convention, 1/125 second is generally considered a safe average speed as long as nothing fast is moving through the frame, while 1/250 second is moderately fast. In any case, what counts above all else is how fast the movement appears within the camera frame (see the table on page 41). For the shot shown opposite of flamingoes in Yucatan taking off (although it was easy to follow them by panning with a long 600mm lens), a high shutter speed of 1/500 second was still needed for the fast movement of their legs and the splashing water. Ultimately, for all the calculations that will tell you what needs what, only the experience of shooting movement often is of any real use.

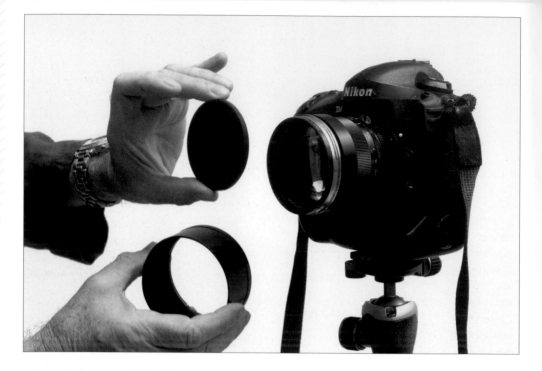

One of the fundamental appeals of shooting at fast shutter speeds is that photography can show slices of time that we cannot actually distinguish in real life. It's why the word "frozen" gets used a lot. This is the appeal of the unusual, even little things like an arc of water spray "frozen" in mid-air. It's about getting the key bit of the action—like a ball, motionlessly sharp—as well as in position and in focus and in time.

What the viewer gets from a frozen image of fast action is the pleasure of contrast. The action is almost always set against a static or slower backdrop, and visually that can be very appealing. In some situations, within the action there's a still-point, such as a mid-air moment, and this has two attractions. One is simply that you can catch it with a slower-than-usual shutter speed. More interesting, however, is that still-points have a natural attraction because they seem to slow down time.

While frozen motion is classic, there's a reverse technique, which is to use a shutter speed so slow that the movement appears streaked in the image; this is called motion blur. It's a mistake if you intended sharp and frozen, but perfectly valid if you want a more impressionistic feeling. Everyone is sufficiently familiar with the appearance of motion blur that it's perfectly acceptable visually. As with fast capture, the shutter speed you need is relative to the action, and it's usually better to be distinct than half-hearted. The most extreme treatment, which has perhaps been overdone, is to shoot bodies of water like the sea, a lake, or a river at speeds of a minute or more so that the water appears to have a soft, mist-like surface. This calls for a very strong neutral density (ND) filter to reduce the light by typically up to 8 or 10 f/stops. Without this, daylight is too strong, even at the lowest ISO and smallest aperture.

It's the Speed In the Frame That Counts

The actual speed of a subject is less important than how fast it travels inside the frame, which sounds obvious but it's easy to be over-impressed by the moving thing (i.e., a racing car, motorcycle, or low-flying jet). If something takes a second to cross the frame, you'll need a shutter speed of 1/500 second to be safe in freezing its movement.

- From the same camera position, a moving subject travels more slowly through the frame with a wide-angle lens than with a telephoto, which magnifies movement as well as other things.
- A smoothly traveling subject, such as a vehicle on a road, moves fastest through the frame when it's moving at right angles to you and the camera, much less when diagonally toward you, and hardly at all when coming straight at you. (That doesn't remove focus issues, though!)
- Parts of subjects can move much faster than you might expect inside the frame, for instance a hand gesture from someone talking, or the blink of an eyelid.
- Panning slows down the in-frame movement of a smoothly traveling subject, but not necessarily its moving parts (such as a cyclist's feet on the pedals).

Opposite & below: Taking slow shutter speed to extremes can convert a heavy sea swell, as here in Mauritius, into the appearance of mist. A shutter speed of 30 seconds at ISO 100 gave this effect, and called for a strong ND filter of 12 stops (in fact a 9-stop ND500 filter plus a 3-top ND64 filter) over the lens to reduce the light at midday, and a small aperture of f/20.

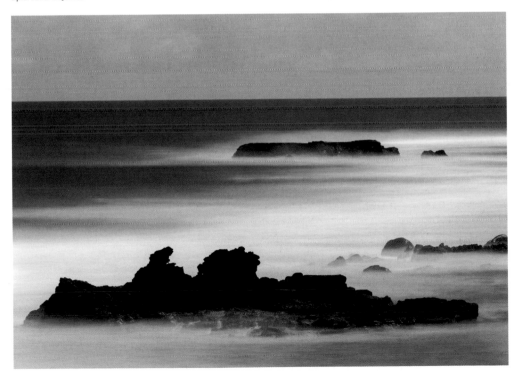

LENSES ARE FOREVER

Now more than ever, your lenses are the long-term investment—not only because digital cameras have built-in obsolescence, but also because it's the optics that give character to the image.

There are practical reasons, certainly, for choosing focal lengths, but more interesting is matching lenses to personality and as a way of developing your own style. Most photographers have a relationship with their lenses that goes beyond the pragmatic. American photojournalist Mary Ellen Mark wrote, "Choice of lens is a matter of personal vision and comfort." Henri Cartier-Bresson believed that 50mm "corresponds to a certain vision and at the same time has enough depth of focus, a thing you don't have in longer lenses," while, according to him, 35mm was way too wide: "[V]ery often it is used by people who want to shout. Because you have a distortion, you have somebody in the foreground and it gives an effect. But I don't like effects." Annie Leibovitz said, "I have to work to avoid getting normal-looking pictures. My favorite lens is the 28mm because it gives me a different perspective with a minimum of distortions." In other words, a lens should be the extension of your individual eye, and it pays to develop an actual feeling for optics.

The main choice is focal length, which sets the angle of view, the magnification, and very definitely a character to the image that you may or may not want to identify with. A simple rule is that the more extreme the focal length, short or long, the more the optics will graphically take over the image.

	Super wide	Normal wide	Standard	Mild telephoto (portrait)	Telephoto	Long telephoto	Super telephoto
35mm	Less than 20mm	20–35mm	40–60mm	70–100mm	150–200mm	300–400mm	500mm and more
APS-C	Less than 14mm	14–23mm	26–40mm	46–67mm	100–140mm	200–250mm	350mm and more

Primes or Zooms?

Primes	**Zooms**
Top optical quality with little or no distortion and no reason for color aberrations	Compromises in sharpness, distortion, and aberrations; generally good enough for most shooting; much can be corrected using lens profiles when processing
Simpler construction, less to go wrong	Heavier, more complex
Capable of wider maximum aperture	Slower than the equivalent prime (longest end of the focal length range)
Fixed focal length means you have to move to change the amount of the scene you cover	Uninterrupted choice of framing
At matched quality, less expensive	Good quality zooms are expensive

Wide, Standard, Long

Focal length is the main quality that sets lenses apart from each other. Shorter gives a wider angle of view, longer narrows it, and which you choose for a particular shot generally depends on what the subject needs and your own personality. The choice may seem somewhat bewildering at a glance, particularly as varying ranges of focal length are now combined in different zoom lenses. As you might expect, however, most photographs tend to be taken with lenses that give a view close to the way we see. Take a look through practically any serious collection of notable handheld photographs—from the first use of 35mm film in the late 1920s right up to today —and you'll see that the great majority of images were (and continue to be) shot with lenses close to standard focal length.

As We See

There's a narrow range of focal length around 50mm that gives an angle of view that most of us think of as basically similar to our vision, and it's aptly named "standard." It's unobtrusive, perhaps even without character, and that's why many photographers choose it. The lens optics don't get in the way of the subject, and that makes standard lenses particularly good for street photography and studio still-life images—two genres that are otherwise poles apart. Optically, there's no agreed "standard" focal length because our vision isn't limited by a rectangular frame so there's no direct comparison. One definition is the diagonal of the sensor (about 43mm); another is the focal length at which the view through the viewfinder looks the same as to the naked eye (but this also depends on the design of the viewfinder). Perhaps the most sensible definition is the focal length that gives roughly what most people would feel is their angle of view. That's around 30°, which is what a 50mm lens on a full-frame camera provides.

Lenses by Subject

Street: Standard to wide-angle is the classic approach, in the thick of things (but see below).

Across the Street: Telephotos are easier for staying unobserved and allow more time to shoot, at the cost of producing a "less involved" shot.

Portrait: Mild telephotos balance flattering proportions for the face with a close working distance that helps rapport.

Interiors: Wide-angle and shooting from a corner is the way to capture a sense of the total space, possibly combined with a standard focal length for details.

Architecture: Using wide-angle, if you're close, will take in the entire structure and its setting. Ideally, add a shift lens to keep verticals vertical (if not, use Photoshop correction later). Add to this a telephoto for picking out architectural details and for long shots from a distance.

Landscape: A moderate wide-angle lens is the all-around ideal choice for typical landscapes, while for panoramas use either an ultrawide-angle or you can do pan-and-stitch with almost any lens. Telephotos give a very different style: distant and compressed.

Still Life: Standard lenses rule in studio shooting, where most images rely on choice of subject, arrangement, and lighting.

Wildlife: Use a telephoto, usually the longer the better, to solve the typical problem of getting close enough to creatures that are either skittish or dangerous.

Sports: Fairly long, fast telephotos get close to the action when shooting positions are strictly controlled.

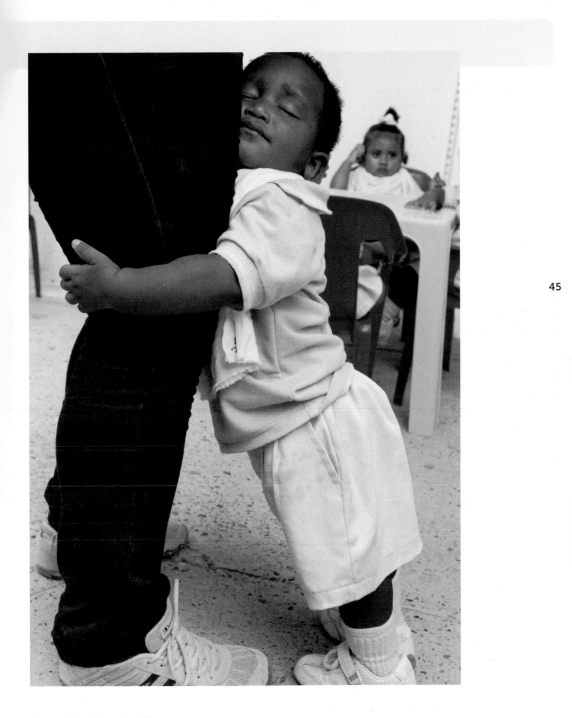

Above: A focal length of 50mm gave a "normal" eye view for a low-level shot in a South American kindergarten.

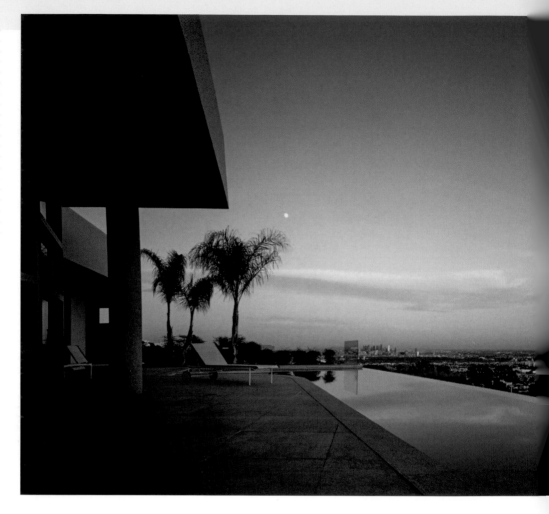

Wide & Immersive

Wide-angle lenses have focal lengths shorter than 50mm, and by general agreement have an angle of view wider than about 60° (and as much as 90°) before we reach the more exotic world of super-wides. On a full-frame camera, the classic wide-angles are 20mm, 24mm, 28mm, and 35mm, each with a long history, but of course these are now included steplessly into normal-to-wide zoom lenses. You can use them simply to get more into the frame, like an expansive landscape or an interior, but getting in close and very personal to a scene with a wide-angle pulls the viewer into the thick of things. It's the still equivalent of the cinematographic "subjective camera." The American photographer Elliott Erwitt said, "The most useful thing about a wide-angle is that it creates a relationship between foreground and background." Distortion close to corners and edges is hard to avoid, and most wide-angle photographers work hard at framing and composing to avoid such deformations as the "egghead effect." To work at its happiest, wide-angle style calls for very good depth of field.

Distance Magnified & Selected

The opposite of the immersive and in-your-face style of wide-angle shooting is the more objective and emotionally cooler effects of using a long focal length. While wide-angle

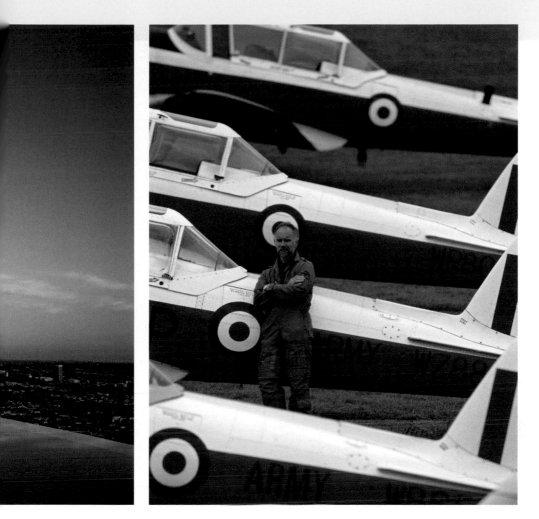

optics pull things apart graphically, telephotos push them together, giving a flattening effect that reduces rather than exaggerates differences in the size of things. This works well for faces (rendering noses and chins no bigger than they should be, hence the long tradition of using medium telephotos for portraiture) and for achieving a compressing effect that appears to enlarge the background. New York photographer Jay Maisel say,s "If you are not paying attention to your background, you are going to screw up anything you are trying to say with your foreground." Shooting this way tends to be a bit standoffish, which runs the risk of distancing yourself from the action in, say, street photography.

Opposite: Modern Los Angeles architecture given a graphic treatment with strong diagonals from a wide 20mm lens.

Above: A 300mm focal length gave a typical compressing effect to a pilot and a row of light aircraft.

48

Lens Extremes

A few photographers have always experimented enthusiastically with the extremes of focal length, at least for a period of time. Bill Brandt, for example, made his famous series of distorted nudes with an extreme-wide-angle lens, and Jay Maisel was well known for his self-proclaimed "telephoto vision." He said, "If I walk around, as I am used to, with a wide-angle and a telephoto, the wide-angle will almost never be on the camera." Even Walker Evans, famous for his "plainspoken" record of 1930s America, occasionally used the compressing effect of a telephoto, fully stopped down, as part of his style of "pure record." Using a wide range of lenses was always a choice of those professional photographers who simply needed to be able to jump from one subject, assignment and creative brief to another. Ernst Haas, one of the 20th century's most influential 35mm color photographers, acknowledged his wide range: "I work mostly with lenses of 21, 28, 50, 90, 180, and 400mm."

Ultra-wide for Full Immersion

There's no hard-and-fast division between normal wide-angle and ultra-wide, but for most people it's around 20mm to 24mm. Wider than this gives an exotic coverage—and distortion. The widest end of a 14-24mm zoom, for example, gives an angle of view greater than we can experience with our own eyes, which can be both useful in some situations and visually exciting. The second effect is an inevitable distortion.

Lens designers work to correct barrel distortion, which with a wide-angle lens causes straight lines parallel to the frame edges to bend outward, like a barrel.

Below: 14mm is the widest focal length in the standard repertoire of zoom lenses for full-frame cameras, here finding a good use for an in-your-face view of a zip-slide over a Chinese river.

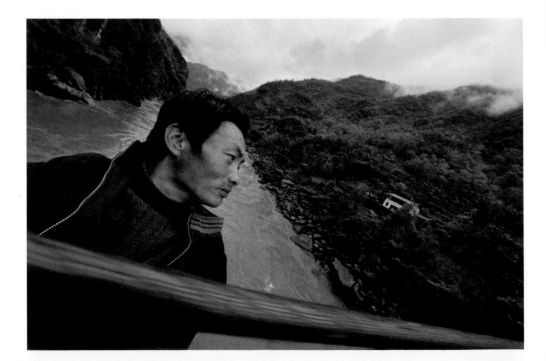

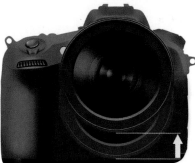

Left & above: A shift lens used for its traditional purpose of architectural photography. The lens, with wider-than-usual coverage, shifts upward to shoot the view upward, allowing the camera to be aimed horizontally and avoid converging verticals.

Achieving this, however, exaggerates another kind of distortion: a stretching outward from the center that becomes more and more pronounced toward the corners. The exaggeration of geometry is at its strongest when you have a very close foreground and a deep shot, but these are exactly the conditions that give ultra-wide lenses their very special character. At 14mm, for example, it's less a matter of how much distortion than where, and the slightest movement when you're framing a shot makes a big difference. An inch to one side can change things dramatically.

Fisheyes for the Widest Possible View

These lenses do exactly what the name suggests, trading straight-line correction for a wraparound view. They were in vogue in the 1970s, with two designs: circular (projecting a circular image on the sensor surrounded by black) and full-frame. The extreme imagery possible has an element of surprise for a while, but the barrel distortion is overwhelming so they don't merit more than occasional use.

Tilt-Shift for Architecture & Focal-Plane Effects

Shift lenses and the even-more-flexible tilt-shift lenses allow you to change the position of the lens in relation to the camera's sensor. Normal lenses project an image circle that is just big enough to cover the sensor, but these cover a wider area, which leaves them with room to spare. Shifting the lens up or down slides different parts of the scene into and out of view. The main reason for wanting to do this is, in architectural photography, to keep verticals vertical. Otherwise, angling the camera upward to take in all of a building makes the sides appear to converge. With a shift lens, you aim the camera horizontally and then shift the lens upward to slide the top of the building down into view. Tilting a lens tilts the plane of sharp focus, which normally is parallel to the sensor like an invisible sheet of glass facing you. Tilt the lens forward, however, as you can with these specialized designs, and what's sharply focused now goes from a close foreground to a distant background.

Above: A Nikon 500mm mirror lens
with a fixed aperture of ƒ/8 is small
enough to hand-hold, and yet allows
close-ups in street shooting from
several meters' distance.

Mirror Lenses for Portability & Affordable Magnification:

The once fashionable mirror lens (aka reflex, aka catadioptric, aka "cat") had its heyday in the 1970s and 1980s and uses optics borrowed from the Cassegrain telescope, which folds the light by means of two internal mirrors. At focal lengths of 500mm and 1000mm, the doughnut-shaped out-of-focus highlights and slight lack of contrast were once admired. Art Kane, once New York's most sought-after advertising photographer, praised "the incredible soft backgrounds. That lens influenced me and altered my vision." Their main disadvantage—a fixed, small aperture of either $f/8$ or $f/11$ that needed a lot of light with normal film—is overcome by modern digital sensors, and these lenses are both light and fairly inexpensive.

Fast Lenses for Low Light & Shallow Focus:

The high-ISO settings possible with modern sensors may seem to reduce the need for a wide maximum aperture, but fast lenses at $f/1.4$ or even $f/1.2$ are not only beautifully bright to work with and allow light to pour in, but used at their maximum apertures have stunningly selective focus. They are, as you might expect, more expensive than regular lenses, and they're generally bulkier because of the extra glass needed. The new breed of exotic high-end lenses from manufacturers like Zeiss and Schneider-Kreuznach include fast lenses designed to work optically at their best when wide open.

Super-telephotos—Beyond the Naked Eye:

Telephotos turn into super-telephotos when they reveal views so small and distant they come as a surprise. That happens at around 500mm, although as it's to do with visual sensation rather than anything scientific, the transition zone is vague. Using one of these lenses (usually long, heavy, and expensive) means training your eye to first search for detail. All the essential telephoto qualities of compression, flattening, and plane stacking are exaggerated.

Close-up Lenses and Macro Optics

Details of small things means entering the world of close-up photography, and for this the key is close focusing. Manufacturers of high-end cameras that take interchangeable lenses each have at least one lens dedicated to close-up shooting, and the optics are designed so that you can focus close enough to magnify to (usually) life size. That means, for example, filling the frame on a DSLR with an object as small as 24mm across—a magnification of 1:1, as it's written. Half life size is 1:2, a third life size is 1:3, and so on. Specialist macro lenses are the ideal solution, because not only do they focus closely, but their optics are designed to perform at their best at these close distances. Ordinary lenses underperform in close-up photography.

Nevertheless, as long as you have an interchangeable-lens camera, another way to focus more closely is to take a regular lens and add an extension ring. This increases the spacing between the lens elements and the sensor, and so has the effect of focusing closer. The table below shows the effect this has on magnification using three available extension rings (in this case, Nikon). Deeper than extension rings— and the next step up in magnification— is an extension bellows, which takes the magnification to larger than life-size and enters the realm technically known as macro. Even so-called macro lenses start to lose performance at higher magnifications, and the solution of this is a reversing ring, allowing photographers to turn the lens front-to-back at the end of the bellows.

As we'll see later (see page 188), close-up and macro shooting bring with them issues related to depth of field. The more you magnify, the shallower your depth of field becomes, and it's optically impossible, for example, to shoot a small sphere at life-size magnification and have all of it sharply focused.

Magnification with Extension Rings

Extension ring	Magnification with 50mm lens	Magnification with 85mm lens
8mm deep	x 0.16	x 0.09
14mm deep	x 0.28	x 0.16
27.5mm deep	x 0.55	x 0.33

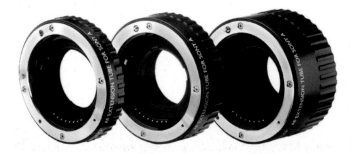

Left: Extension rings magnify by positioning the lens farther away from the sensor.

Opposite: Macro often results in an abstract representation of your subject, accentuated by the vanishingly small depth of field at such high magnification levels.

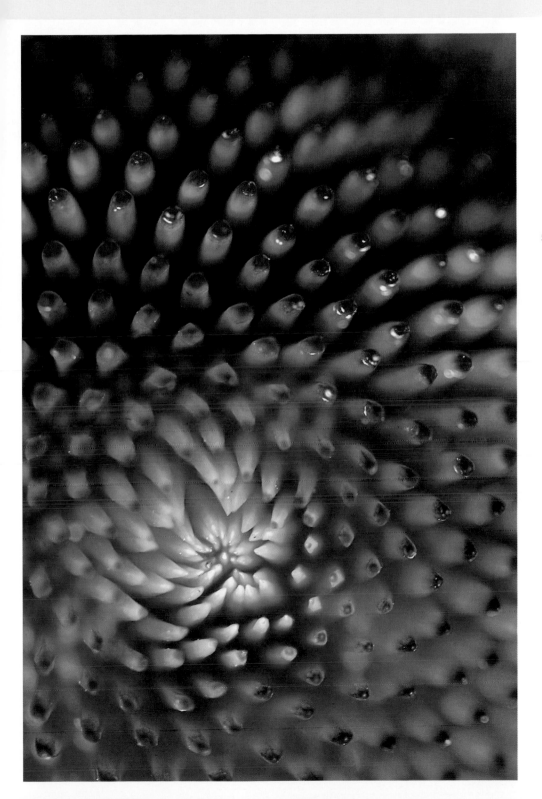

APERTURE FOR DEPTH

Just as the shutter speed does two jobs (controling how motion appears and letting in more or less light to the sensor), so too do the aperture blades in a lens. They control the amount of light entering, but they also alter the depth of field—the range of distance in front of the camera in which everything looks acceptably sharp.

54

It can be deep, covering the entire scene, or it can be shallow, with only a narrow band sharp and the rest blurred. It's a term that we trundle out at the drop of a hat, as if it explains all that's needed about lens apertures, but when it comes to shooting it's much more about why than the what.

The reason why depth of field needs explanation in the first place is that, perhaps surprisingly, it is a visual effect we have very limited experience of with our own eyes. Normal, healthy eyes simply see everything as normally sharp. If you're short-sighted or long-sighted (that's more than a third of us these days), then unaided you'll have some sense of blur, but it's unlikely to come anywhere near the smooth wash of blur in a selective-focus shot or in almost any macro background. That's why well-managed blur can be so appealing; it's beyond our usual visual experience.

Opening the aperture to its maximum gives the shallowest depth of field, closing it to the minimum gives the deepest. It does not change with focal length, but using a telephoto to magnify a small part of the

f/stops

The notation for aperture size is the f/stop. The smaller the number, the wider the aperture. Lenses are described partly by their maximum aperture, and it's an important figure because the wider the lens, the easier it is to use in low light (and the more it costs to manufacture!). An aperture of f/2.8 is typically normal. In the days of mechanical lenses, you could click up and down as you turned the aperture ring and know exactly by feel how much more and less light you were letting in. As the shutter speed was stepped in the same way (1/60, 1/125, 1/250 second, and so on), clicking the aperture one way and the shutter speed the other way gave exactly the same amount of light. This is known as reciprocity. Digital operation nowadays is less crude, but the notation has stuck.

f/1.4 f/2.8

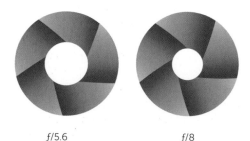

f/5.6 f/8

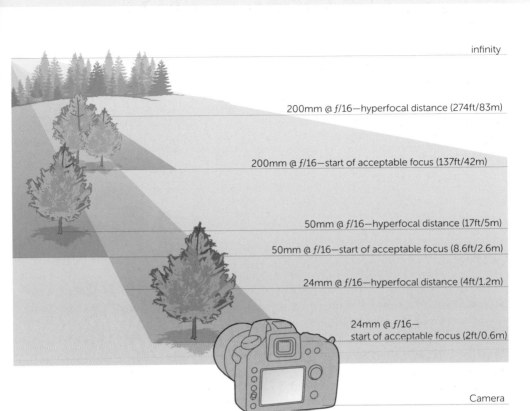

infinity

200mm @ *f*/16—hyperfocal distance (274ft/83m)

200mm @ *f*/16—start of acceptable focus (137ft/42m)

50mm @ *f*/16—hyperfocal distance (17ft/5m)

50mm @ *f*/16—start of acceptable focus (8.6ft/2.6m)

24mm @ *f*/16—hyperfocal distance (4ft/1.2m)

24mm @ *f*/16—
start of acceptable focus (2ft/0.6m)

Camera

scene gives the impression of shallower depth of field. It's also related to the size of the sensor. Due to the way we see, full depth of field is our default, and it's also normal with a smartphone because of the small lens and sensor. At its most mechanical and predictable, depth of field is used to keep the important parts of a subject sharp, but there are many more interesting ways of using it. Our attention naturally goes toward the sharpest parts of an image, and you can use that to direct the viewer's eye, but equally, by throwing some things unexpectedly out of focus, you can disrupt and challenge the viewer's expectations. Ultimately, using depth of field creatively means playing with contrast—the contrast between sharp and blurred. We'll see this in action later on pages the following pages.

Making the Most of It with Hyperfocal Distance

If you think of the plane of sharp focus as a large sheet of glass flat in front of you, its thickness is the depth of field. Shallow depth of field is like a thin sheet of glass, while deep is very thick. The actual plane of sharp focus is not exactly in the middle, but closer to the camera—on a normal landscape scale, about a third of the way into the scene. To get the maximum depth from the horizon forward to the camera, the focus needs to be nearer than the horizon itself, otherwise you'd be wasting some of it. This distance is known as the hyperfocal distance.

FOCUS FOR ATTENTION

Sharp focus has always been enshrined as the first absolute necessity in taking a photograph. Remember that sinking feeling when you magnify a great moment only to find that it's slightly soft where it shouldn't be?

It's hard to argue that the subject you're concentrating on shouldn't be pin sharp. Optically, focusing means moving the lens (or more usually some of the lens elements) farther from or nearer to the sensor. Closer puts the focus farther away, while for nearby objects the lens elements have to move forward, away from the sensor. The solutions for getting this right every time are all in place with sophisticated autofocus, and high-end DSLRs use methods like predictive tracking to stay locked on to a moving target. The how of focusing is sorted, but the where and why are your decision. Moreover, focus is more critical with shallow depth of field and a wide aperture, while stopping down the aperture for depth makes it less important to be precisely focused.

Mostly we know what we want to be sharply focused, but sometimes a different focus point may challenge the viewers' expectations. As with shallow depth of field, it's the contrast between sharp and blurred in the same image. The eye goes naturally to what's sharp, while the out-of-focus areas can make an attractive soft wash. One of the most satisfying things visually that focus can do is to make a clear separation of planes in an image, and it calls for quite personal judgment. The idea is to make your focused subject prominent by contrasting its crisp edges with a softened

Below: Reversing the usual technique of focusing on the foreground subject challenges viewers' expectations, but depends on the blurred foreground being eventually recognizable

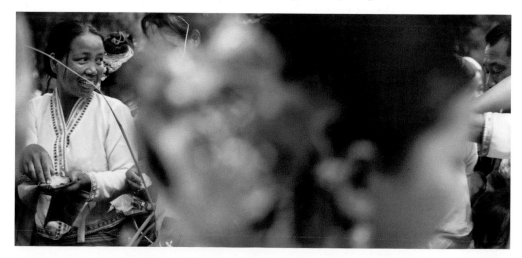

backdrop. There's nothing startling about this, but managing it means handling several variables, including focal length, aperture, the exact point of focus, and the actual physical separation between the subject and background. This last quality means finding the right viewpoint, and typically you would be looking for an empty space behind the subject so that the distant background is all at more or less the same degree of focus blur. Taking it to extremes means using a fast lens, wide open for what's called selective focus, in which only one tiny part of the image is sharp.

Below: A Photoshop technique with tripod-mounted still-life shooting allows selective focus at more than one point. Here, the photograph in the upper layer is focused on the blackberries, but erasing a hole allows part of a second shot focused on the pastry (below) to show through.

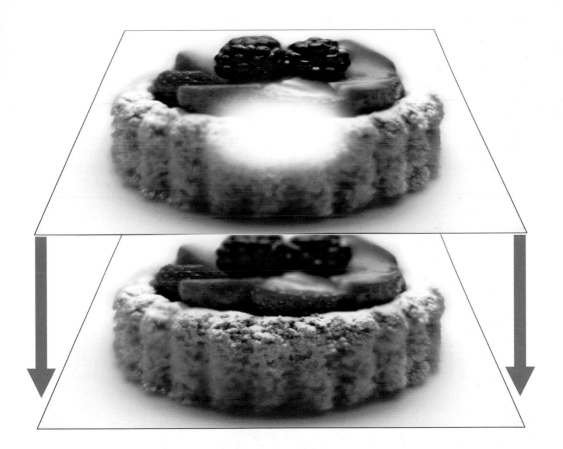

TRIPODS FIX

High ISOs and vibration reduction have not killed tripods. We may need them less often for basic low-light situations, but to make up for this, digital has introduced new ways of shooting that rely on holding the camera motionless between shots.

Overall, tripods remain a part of the toolkit for most serious photographers, and like almost everything else in photographic equipment, they have evolved in recent years to be even more compact, lightweight, and versatile.

A tripod has one job in life: to hold the camera perfectly still. There are more occasions for wanting this than you might expect, though the most basic is for shooting at a slow shutter speed because of low light—slower than you can reliably handhold the camera without moving. Low light happens at dusk and beyond, but also indoors. If you need a low ISO for a noise-free image together with really good depth of field from a small aperture, that too will demand a slow shutter speed.

Beyond this basic need, however, are the increasing number of situations where you need two or more frames to be in register—framed exactly the same without any shifts. Digital processing and post-production has created a new category of shooting in which different frames are stacked in the computer. HDR is one (see page 94), focus stacking is another (see page 90), and indeed it is necessary for any way of treating images that involves placing them into one image file as a stack, such as using a Photoshop stack mode to make passersby disappear from a scene.

Left: The three-way head shown far left allows you to very precisely set your camera's support, though it can be quite fiddly and require a lot of small adjustments to reach the angle you desire. A ball head, on the other hand rotates freely in all directions and can be set much more quickly, if less precisely.

This page: Tripods range from the small and travel-friendly (the Joby Gorillapod is a classic example), to the professional and sturdy (the carbon-fiber tripod in the middle). For very quick setups, the monopod at the far right gives a lot of flexibility, at the cost of a truly stable support (you must continue to hold the camera). At the bottom of the page, you can see this Manfrotto tripod's center column can rotate 90 degrees, which helps achieve difficult angles, such as those often used in macro shooting.

A Tripod's Many Uses

- Shutter speed below the camera-shake threshold
- Multi-shot techniques (i.e., HDR, focus stacking)
- Precision framing
- Extended shooting (i.e., sunsets and sunrises)
- Awkward viewpoints (i.e., directly overhead or ground level)
- Remote triggering
- Heavy equipment

LEAN EQUIPMENT

Beyond tripods, the array of other equipment that you can add stretches as far as your love of gadgetry—and as far as your wallet allows.

Accessories are addictive because they can all be justified, but it's best to distinguish between what is essential to your way of shooting and what only might be useful. If you're going to be on foot as opposed to being in a studio or working out of a vehicle, the general idea is to keep it lean and to the minimum.

One advantage of digital is that functions that used to need an accessory are increasingly being built into cameras. A spirit level, for example, is replaced by a virtual horizon, and a pocket flashlight for checking settings in darkness has been replaced by backlit display screens. Nevertheless, the various ports on a digital camera, from USB to HDMI, are an open invitation to third party manufacturers to make bolt-ons that (sometimes) you never knew you needed.

2.

1.

3.

Do We Still Need Light Meters?

Given the effort that all camera manufacturers have put into guaranteeing a good exposure, you might wonder why anyone would bother any more with a handheld light meter (which, way back, all professionals used). The reason is that only one of these can measure incident light readings, meaning the light that falls on a scene or subject regardless of how light or dark they are. Camera meters measure the light reflected from a scene (entering the lens, in other words). That runs into difficulties when the subject is much lighter or darker than average (black cats and snowdrifts). Smart metering (see page 20) solves this in clever but complicated ways, but the simplest answer is to ignore the brightness of the subject and just measure the light. Fitting a translucent plastic dome to the handheld meter and pointing this at the camera gives you a substitute reading that will ignore variations in scene brightness. In short, yes, light meters are still an essential part of any photographer's toolkit.

Opposite & left: 1. A dual-battery charger literally halves the time spent charging batteries, allowing you to leave them charging without having to swap one out for the next. 2. A light meter makes flash-output calculations a cinch. 3. A portable battery pack can charge smaller cameras anywhere, anytime. 4. The Eye-Fi card broadcasts a wifi signal that allows easy transfer of images to your smartphone or tablet. 5. A hoodman loupe fits over the LCD to make it visible in direct sunlight. 6. A simple microfiber cloth ensures you can keep your lenses clean and unscratched. 7. Step-up filters allow you to fit larger filters onto lenses with smaller filter threads, saving time and money. 8. A variable ND filter can cover a range of ND strengths in a single package.

LIGHT IT UP

Most of the time we work with found light, varieties of daylight or artificial light in streets and interiors. It's the uncontrollable given that photographers react to.

Lighting, on the other hand, is what a photographer creates, quite often in an attempt to reach a natural-light effect, but sometimes to create a unique style of illumination. You can do this out in the real world, adding to what's already there, substituting with portable flash, or for maximum control, creating lighting in a studio space that is otherwise dark.

As lighting is the major photographic ingredient that studio conditions offer, it's hardly surprising that the choice of lamps, fittings, and accessories is greater than in any other category of equipment. The many different kinds of lamps, the constructions to house them, the different shapes, and the varied diffusing and reflecting materials on the following pages make up the most equipment-oriented area in all photography.

The lighting quality from each piece of equipment is distinct, even if subtly so. The differences are in the degree of diffusion or concentration, the shape of the light as it falls, the sharpness of the shadow edges, the evenness of the lighting pattern, and other, similarly delicate qualities.

Moreover, this subtle degree of choice is absolutely necessary. In outdoor location shooting, there is a rich variety of lighting conditions and, as viewers of photographs, we are used to seeing such complexity of effect. In building a lighting pattern from scratch in the studio, however, there is some risk of being unsubtle simply through having to work with light sources that can only be adapted to a limited degree. A full selection of lighting equipment expands the range of studio subjects that can be handled, and their individual treatment.

Above: A professional flash unit not only offers plenty of manual controls, as seen here, but also cooperates within the manufacturer's whole ecosystem of flash equipment—in this case, the Nikon Creative Lighting System.

Camera Flash

On-camera flash is almost certainly the most widely used type of photographic lighting, but it suffers the limitations of a small light in a frontal position. Extremely useful for reportage and impromptu situations where the overall lighting cannot be controlled, it is rarely the style of choice for formal portraiture and still-life photography. Being portable and mainly automated, on-camera flash has the advantage of offering instant, easy lighting. By the same token, however, it is not capable of great subtlety, and the small size of the flash tube is frequently a problem. There are two further problems. The first is that light falls off away from the camera, so that the correct level of brightness is only possible at a certain distance; anything closer will be overexposed, while backgrounds at any real distance are invariably dark. Digital cameras with integrated flash use various strategies to overcome this, including measuring the distance to the main subject by linking to the focus setting, and by varying the spread of the beam to match the focal length, but foregrounds will always be overexposed and backgrounds underexposed. The second problem is that this type of flat lighting does not suit very many subjects, and can produce red-eye reflections (caused by light reflecting from the retina). More often than not, these effects are a nuisance, although there are occasions when the rapid fall-off can be used to isolate a subject.

The principal use of portable flash is as fail-safe illumination—making an inadequately lit shot possible. In news photography and reportage work in general, the subject is often much more important than creative considerations and if a camera-mounted flash unit is the only way of capturing an image, then its aesthetic defects are secondary. It is also useful for fill lighting—relieving shadows in a high-contrast scene. Backlit subjects, for example, always have high contrast, and if it is important to preserve shadow detail, some extra light will be needed. Fill flash works most realistically when used at a relatively weak setting, so that it does not compete for attention with the main source of light. A typical ratio of flash to daylight would be about one to three or one to four; how this is achieved depends on the particular unit.

Solutions to the flat, frontal lighting effect either involve bouncing the light or taking the flash away from the camera. If there is a large, light-toned surface nearby, such as a white ceiling or wall, this can be used as a reflector to soften the light, by aiming the flash in that direction rather than straight at the subject. Flash heads tilt and swivel for this reason. Holding the flash head on an extension lead away from the camera is an alternative way of varying the lighting effect. This can also be combined with other flash units linked by infrared or RF for a multiple lighting effect—but at this point we are no longer dealing with on-camera flash. The new generation of dedicated flash units can be used in multiples and without cables to create sophisticated lighting set-ups on location.

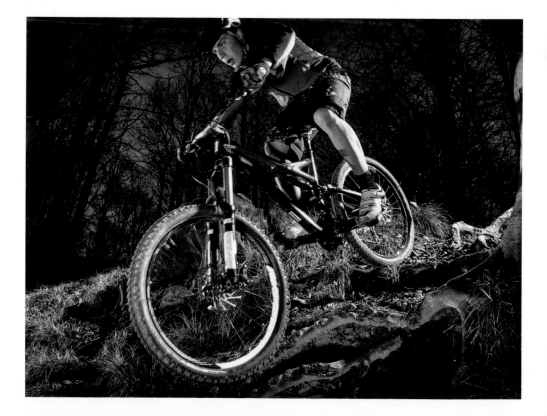

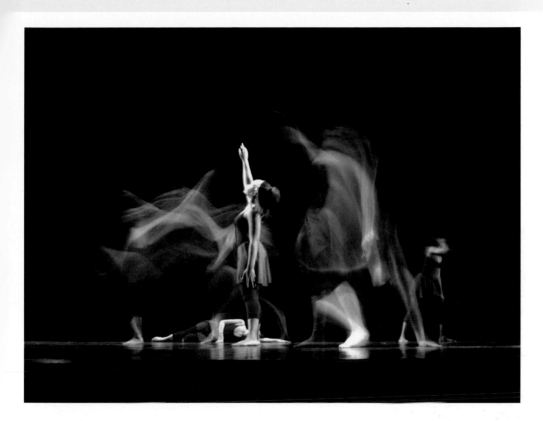

Rear-curtain sync is the one genuine lighting contribution from on-camera flash, in which the flash is timed to fire at the end of a long exposure. The purpose is to combine ambient lighting (in a relatively dark situation) with the crisp legibility of the flash, and as the flash image 'closes' any sequence of movement, whether of the subject or the camera, the effect can be compelling.

Above: This example of rear-curtain sync shows how you can capture both motion blur and a sharp final gesture in the same shot.

Opposite: With action photography, your flash can actually serve as your shutter speed—in this case, the aperture was closed down all the way to $f/14$, with a low ISO of 50, and a shutter speed of 1/200 second—too slow to sharply capture the subject. What actually caught the subject was the flash firing at just the right moment.

Studio Light Sources

Joe McNally notwithstanding, camera flash is meant for simple accompaniment in whatever location you find yourself. Totally constructed lighting, however, is what defines studio shooting, and whether it's a portrait or a still-life product shot, there's a large choice of serious lighting equipment to meet any need. As you might expect, this is a largely professional world and it's costly, but there are also many reasonably priced brands that work well. The basic choice is the type of light source, and there are more now than there used to be, but there's still a basic division between flash and continuous.

At one time, high-powered flash was the undisputed king of studio lighting, not the least of which was because film was slow (like ISO 50) and studio cameras used really small apertures (like $f/32$ and $f/45$). Digital has changed all this because better sensitivity and smaller cameras has reduced the need for the massive explosions of flash that were once common, and continuous light sources are now many photographers' first choice. The great advantage of continuous is that you see exactly what you get as opposed to having to guess and use experience with flash units. Some of these lamps are intended for you to add light modifiers to them, but some come already built into modifiers. As it's the modifiers that are the key to light quality in a studio, we'll show these pre-fitted lights on the following pages.

Studio Flash:

The one thing that flash alone can manage is freezing movement, and on a large scale if necessary, such as a group of people in action. If this is what you need, there's no other choice. Most modern flash units are self-contained (monolights), and although bulkier than a camera-mounted flash, still easy to fix. They are intended to be fitted with light modifiers (read on for details) although bare-bulb flash has a specific, stark quality.

Pros	Cons
Freezes movement	No exact preview
Cool, no heat issues	Fiddly to mix with ambient
Daylight rated, mixable with other sources	

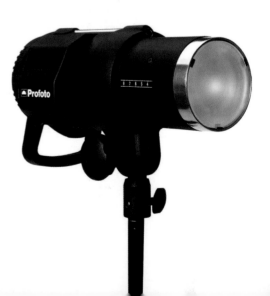

Tungsten:

Continuous used to mean only tungsten lamps, rated at 3200K (orange compared to the daylight rating of flash at around 5000K). Being hot, particularly when switched on for an hour or more, they cannot be fitted with boxes or other light modifiers that enclose them. Heat output also makes them difficult to use close to things that can melt, like ice cream (or a model!). Nevertheless, they output a lot of light for their size, and the lamps can be small enough to work very well with spots and other ways of concentrating the beam. For decades the main light source for the movie industry, they come in a large variety of units, some very powerful, all the way from Reds to Blondes and beyond.

Pros	Cons
Strong output	Hot for subjects
Relatively inexpensive	Too hot for enclosing fittings
Many kinds available	Needs gels to mix with daylight

Fluorescent:

Fluorescent technology, basically in the coatings, has improved way beyond supermarket standards, and daylight-balanced tubes are a relatively inexpensive, efficient light source which, because of the size of the tubes (usually in a side-by-side array for an area light), is softer than tungsten or HMI.

Pros	Cons
Cool	Heavy
Daylight balance	Bulky
Bright (4:1 efficiency vs. tungsten)	Less throw than HMI or tungsten
Softer than HMI	

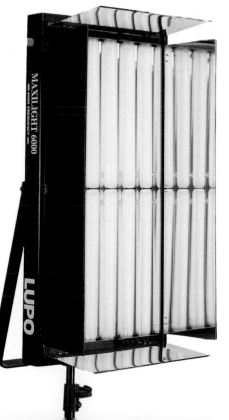

LED:

The newest kind of continuous lighting, each LED is typically 5mm and round and they are used in arrays. Used close, they throw multiple shadows, so for soft use they need to be fronted with a translucent panel. Some models have translucent panels already fitted in the form of a box.

Pros	Cons
Cool	Expensive
Bright	Not yet available in very large arrays
Adjustable color temperature	Need heavy diffusion to hide the individual hotspots of individual cells
Lightweight	

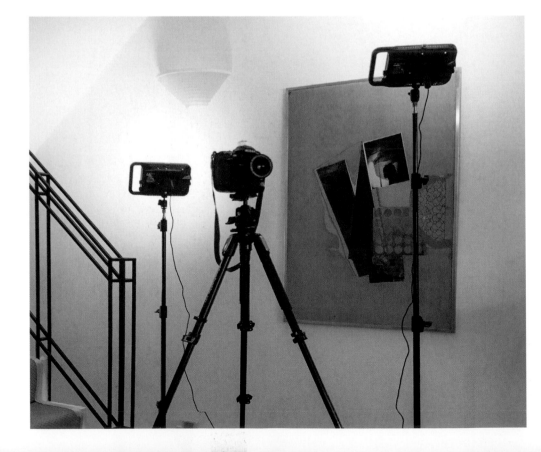

HMI:

HMI is actually a trade name but is widely used to describe metal halide lamps. Efficient, strong, hard continuous lighting (though bulky and heavy), the lamps are small and powerful. They are a hard-light source like tungsten, but daylight balanced. Electrical supply needs attention, as ballast must be flicker-free.

Pros	Cons
Cool	Heavy
Daylight balanced	Needs flicker-free ballast
Bright (4:1 efficiency vs. tungsten)	Hard
Strong throw	Expensive

Light Modifiers

Almost all of the lights detailed on the previous pages are intended to be modified rather than just used as harsh point-light sources. This is essential in order to be able to control the quality of light, as we'll see later (see "Constructed Lighting" on page 134). The exceptions are lamps that are specially built into their own fittings, such as Fresnel spotlights and troughs.

There are basically four kinds of modification: You can diffuse the light to make it softer and broader, you can reflect it from different surfaces to broaden it or fill shadows, you can block part of it with flags, and you can concentrate it to intensify and sharpen. Of the four, diffusion is the most in demand because softer light is the most conventionally flattering to people and objects.

Diffusing:

The principle here is to fit a sheet of translucent material at sufficient distance in from of the lamp so that there is no hotspot and the material itself becomes the light source. The most common materials are opal Perspex/Plexiglas (available in different strengths, with 030 as the most common), white fabric (i.e., cotton, sailcloth, or muslin), spun fiberglass, frosted glass, and tracing paper. All of them increase the area of the light source and weaken it.

- Area light
- Translucent umbrella (to shoot through)
- Diffusing panel
- Honeycomb and egg crate (hard or fabric, both black)
- Scrim, spun, and silk (usually on a frame, can be DIY)
- Yashmak

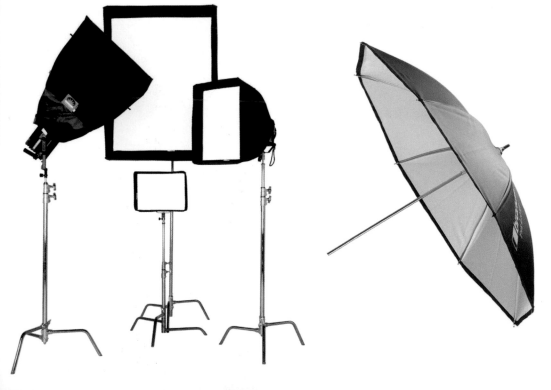

Reflecting:

An alternative method of broadening a light source is to reflect it (although that is not a reflector's only use). Bounced illumination is always much weaker than direct light from the same source, but if the surface used is large and white, the effect is extreme diffusion. White ceilings and walls, for example, with a lamp aimed at each, can provide virtually shadowless illumination.

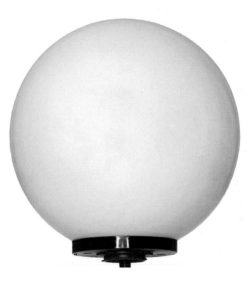

- Bowl and spiller cap (aka beauty reflector; for diffusing effect)
- Flood (i.e., floodlight reflector)
- Collapsible reflector (handheld on location)
- Umbrellas (most common studio reflector, inner surface varying from white to silvered)
- Flats (usually white, in polystyrene, plywood, thick card; suitable for DIY)
- Rolling flats (mounted on wheels)
- Cupboards (flat with sides and top added to contain light spill; good for full-length portraits)
- Baking foil (useful DIY reflector, can be crumpled then smoothed for softer effect)
- Mirrors (small ones useful in still-life shooting for local fill or catch-lights)

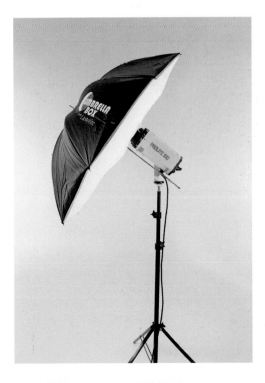

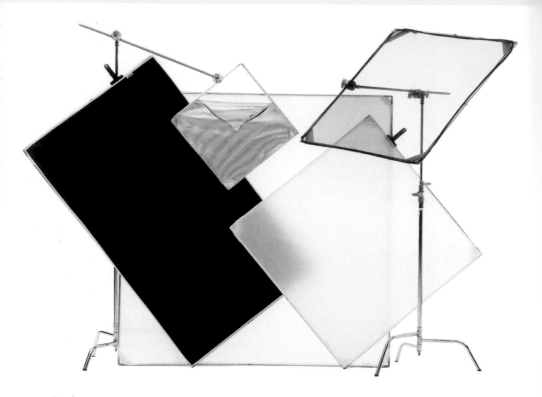

Flagging:

Basically, these are sheets and shapes of any fairly rigid black material at different sizes used to partly block the light.

- Flags (rigid black shapes; dots, fingers, and cutters are shape variants)
- Black scrim (usually on a frame)
- Cookie (short for cucaloris, a screen with a dappled pattern)
- Gobo (patterned stencil to control light shape and cast precise shadows)

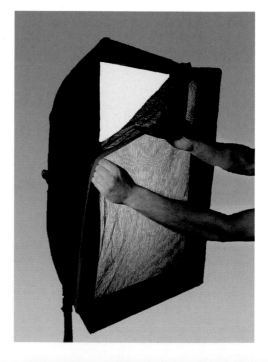

Concentrating:

The opposite of diffusion, concentrating focuses the light onto a small area for a spotlit effect with sharp, definite shadows and a distinct shape. A lensed spot is the most precise and controllable.

- Cones or snoots (the simplest method, though imprecise)
- Barn doors (masks the spill of light from a lamp)
- Fresnel spotlight (most common, with a thin lens composed of concentric rings, to focus the light; originally for tungsten only, now can fit fluorescent and LED)
- Lensed spot (aka optical spot; allows focusing for precision and control over light shape and definition; stage lighting versions are known as Ellipsoidals)
- Fiber optic (attachment to channel light precisely on small scale; for still-life)

Fixing Lights

Stands:

The standard lighting support for most studio lamps is a tripod stand, and for the typical three-quarter-top position used in many lighting arrangements it is the most convenient. High and low positions, however, increase the variety of lighting quality and call for different stand sizes. A rolling castor stand is the easiest to move around in a permanent studio, but a collapsible stand can be stacked when not in use. For stable high positions, a wind-up stand is useful.

Counterweighted Boom:

This lighting boom has a much greater variety of positions, from very high to very low, including the important position of directly overhead. The counterweight can be adjusted by sliding it along the boom, by sliding the entire boom in its collar, or by adding or subtracting to the weight itself. Boom stands need care when being moved as they may overbalance.

Safety Cable:

A useful precaution when suspending heavy lights overhead is to attach the lamp separately to another ceiling or wall fitting with a wire or strong nylon cable.

Extension Arm:

A bar attached to a standard locking collar fits onto any regular light stand and enables a lamp to be aimed more downward

Pantograph & Celing Track:

A pantograph operated manually or by an electric motor gives adjustable height and keeps lighting off the floor. It is normally used with a ceiling track. These free up floor space by keeping lights and cables high (ceiling power sockets are useful). They're best for overhead positions and large lighting fixtures.

Wall Boom:

A simple swiveling arm can be stored flat against the wall or swung out to take a single lamp.

Expanding Sprung Pole:

This telescoping pole, padded at either end to give a firm grip, contains a powerful internal spring to lock it firmly between floor and ceiling.

Goalpost Arrangement:

This is a simple DIY method of fixing a large light overhead. A pole is clamped horizontally between two regular stands and the light is then clamped to that. Goalpost arrangements are useful for still-life tables, with the stands on either side.Pantograph: A pantograph operated manually or by an electric motor gives adjustable height and keeps lighting off the floor. It is normally used with a ceiling track.

AGILE SHOOTING

There's never been such a wide range of cameras, lenses, and accessory equipment as we have now, and with increasing manufacturer pressure to "improve" your photography by adding to your collection, there's a noticeable increase in Gear Acquisition Syndrome (GAS).

How much, in items and weight, do you actually need to shoot effectively? Of course, it's bound to vary according to the kind of shoot, from a static studio to shoe-leather street shooting, and on specialized needs like a fast telephoto for sports.

One useful principle is: just enough and no more. This means balancing choice of equipment for what you anticipate you'll need (particularly lenses) against a load that will actually slow you down and, if you're out walking for a few hours, wear you down as well. Rather than work from manufacturer suggestions, which will always encourage you toward more, take a clear look at how you typically shoot:

- Is your shooting usually planned or unplanned?
- Do you work spontaneously on foot, or in a more considered way from a vehicle?
- Is one camera body enough?
- What proportion of your shooting can you manage with a single lens?

Cases

If traveling to your shooting destination is an important part of the trip, it may be more secure to pack the equipment well, then unpack items as needed when you arrive. Waterproofing and impact resistance are key qualities, typically from polypropylene or other high-impact plastic with padded interiors. Carry-on versions meet IATA dimensions.

All of these questions are personal ones, and it's important to tailor what you carry and how you carry it exactly to your own needs. A professional on a commercial assignment might well have an assistant or two to carry gear and hand it over as needed, but most of us need to manage our own. Here are some more practical questions you should ask yourself:

1. Do you need a second camera for shooting, or just to have packed as a spare? The two arguments for a second camera are first, to switch instantly to another lens instead of changing lenses, and second, for different sensor abilities, like higher resolution for slower subjects like architecture or landscape.
 Note: Running two camera systems side by side is almost always impractical. Better to choose one system (like DSLR or mirrorless) and stick to it.
2. What subjects are you likely to be dealing with on an upcoming shoot, and which lens(es) will they absolutely need?
3. How likely or not is a shooting opportunity that would need a special lens or a tripod, and can you risk missing it or shooting it with more difficulty?
4. Operationally, are you more comfortable working strap-based or bag-based?

Carrying Options

Simple Strap
- usually shoulder/neck but also wrist
- combine with a shoulder bag for one camera and lens on the strap, others in the bag

Sling Strap
- normally worn over one shoulder with camera hanging from a base plate at hand level when arm is fully down

Belt and Plate
- relieves pressure on shoulders
- camera clips onto a holster-like arrangement

Chest Harness
- like a belt but different weight distribution

Holster Bag
- like a belt but more protection for camera
- slightly slower access than belt

Shoulder Bag
- traditional solution
- some risk of shoulder strain

Backpack
- many options with varied access (top-loading is popular)
- best for slower stop-and-shoot situations like trekking
- offers full equipment protection in inclement weather or moisture-prone shooting situations (such as on a boat)

TIDY WORKFLOW

Workflow in photography refers to the sequence of progressing an image from the camera through to the final way you use, store, distribute, and display it. There's nothing particularly complicated about workflow; it's simply a matter of following ordered steps, and you can plan these to suit your way of shooting.

They'll be different in detail if you spend most of your time shooting at home or in a studio rather than out on location for a week or two at a time. In other words, how you handle your image files from shooting through to archive and backup will depend on your style and volume of photography. There isn't a single workflow to suit everyone.

Workflow Hardware

Computer
This can be a desktop computer or a laptop, with the latter being far more common, due to the combination of portability and performance. Increasingly, you're also able to use a tablet for basic importing/tagging/processing in the field or while traveling, but even then, you will need a dedicated computer at some point.

Card Reader or Direct USB
Most people use a card reader to transfer images to a computer or storage, but some computers have built-in reading slots. Alternatively, use a USB cable to connect camera to computer.

External Hard Drive
This is thee most common basic storage device. It is normally either small and portable and used for temporary backup (such as if you're out shooting for a day or so in the field) or permanent and larger and used for file backup at home or in the studio.

RAID

Your computer's hard drive is not the ideal space for an archive due to space limitations, possibility of a crash and, if you use a laptop rather than a desktop computer, its portability and "thievability" put it automatically at risk. The safe and professional storage device is a RAID (or equivalent). RAID stands for Redundant Array of Independent Disks and contains several hard drives that are configured so that the single files are stored across all of them. This means that, depending on what configuration you choose, when a single drive fails, nothing is lost. You can choose the level of redundancy, and typically you'd set aside a quarter of the total space for this. Drobo uses its own proprietary system similar to RAID, and drives are "hot-swappable."

Network Attached Storage

Cloud storage has the advantage of giving you (and anyone else you designate) remote access to images, as well as being another safe location to keep copies. Network Attached Storage (NAS) lets you set up your own remote storage that's directly under your control, and affordably. Units such as Western Digital MyCloud series, and NetGear ReadyNAS are basically inexpensive computers with storage bays for two or more hard drives and they connect directly to your WiFi. Easy to configure, they can be accessed by all your different devices, including your laptop when you're traveling.

Workflow Software

The easy route when it comes to workflow is to do all or most of it through one piece of software. Adobe's Lightroom is the most comprehensive, from processing to organizing and distributing. Trailing a little behind on the workflow front, though excellent for processing, are Capture One from Phase One and DXO Optics Pro. The other way to do workflow is using one program per job, as in Photo Mechanic for downloading and captioning, followed by Photoshop for processing and post-production, then Media Pro for cataloging.

Archive vs. Backup

Your image archive is where you store your files for easy access to work on them, review them, send them out, and so on. Depending on how many you have, the archive will typically be on a RAID. You might consider separate folders for Raw and processed/edited images. Backup is where you keep copies of images for safety, not for use. You should have at least one backup device (typically an external hard drive) onsite and one off-site. Off-site means at a different physical location, like another building, in case of fire, flooding, or other calamity.

Sample Workflows

Workflow #1: One-Day Location Shoot

1. Transfer the images from the memory card in the camera to your archive (such as a RAID) via your computer at the end of the day.
2. Rename the images according to any sensible system that suits you, ideally as you transfer.
3. Fill in all useful information about the image as IPTC Metadata, including caption, keywords, and location.
4. Make copies of the named and captioned images onto your backup hard drives.
5. Review and select the best images.
6. Open and process the selected Raw files.

Workflow #2: One-Week (or Longer) Trip

1. At the end of each day, transfer the images from the memory card in the camera to your laptop.
2. Rename the images according to any sensible system that suits you, ideally as you transfer.
3. Fill in all useful information about the image as IPTC Metadata, including caption, keywords and location.
4. Make copies of the named and captioned images onto at least one but preferably two portable hard drives.
5. Delete images from the memory card (by reformatting) only when you have both downloaded them and made completed all backups.
6. If you have time, select the best images each day, open and process them.

Workflow #3 Studio/home shooting

See Workflow #1 but consider tethered shooting, which records images directly from camera to computer, bypassing the memory card altogether.

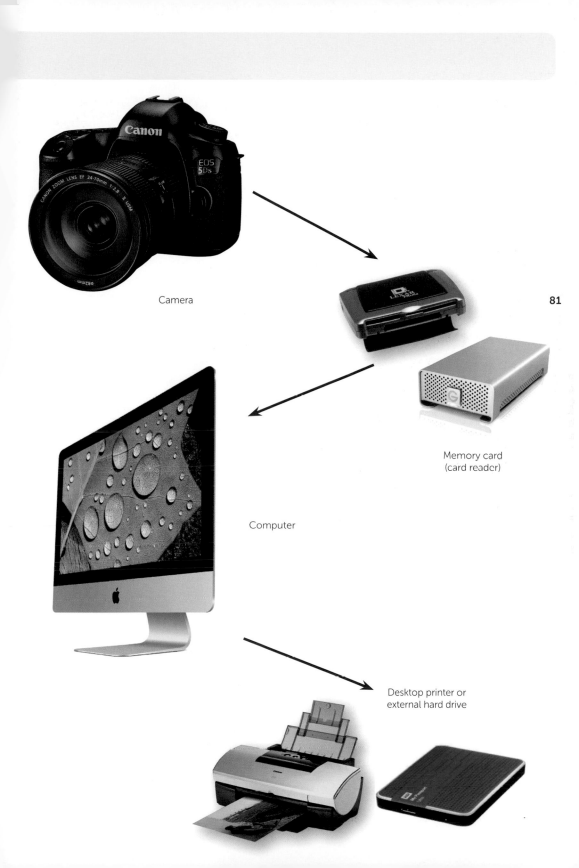

Camera

Memory card
(card reader)

Computer

Desktop printer or
external hard drive

File Naming & Folders

Perhaps surprisingly, the important thought that has to go into the organizing of images has very little to do with computers and software. You can make all the important decisions about how you're going to arrange your collection of photographs in your head, or on a scrap of paper. The first decision is where exactly on the computer or storage device you will put them, and this will certainly mean nesting folders inside other folders. The second is a naming system, which means a plan for filenames that you can use not only for all the images you have already taken, but the many more you expect to take.

A typical method for folders is to nest them in a tree-like structure, with sub-groups sitting inside higher-level folders. Much depends on the kind of photography you do, but the two most common ways are travel-oriented and subject-oriented. If you specialize in a particular subject, then that will almost certainly define the way you group images. A travel-oriented folder hierarchy might go CONTINENT > COUNTRY > REGION, while a subject-oriented example could be NATURE > MACRO > INSECTS.

As for naming, keep it different from the folder structure. Numbering is the simplest, and you could combine this with, for example, years or trips. By year, the file naming could go 2017_001 etc. You can add simple titles to a filename for an individual picture; imagine how someone else unfamiliar with your archive would want to search. Provided that you give sensible filenames and write essential keywords, anyone can search for an image using whatever search method the cataloging software offers.

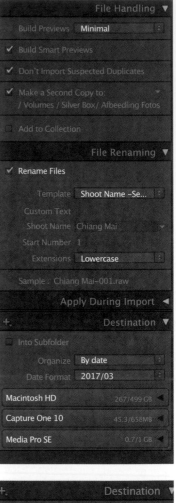

Above: This File Handling Import window from Lightroom shows how you can rename files as they are being imported—automating the process and standardizing your filenaming conventions.

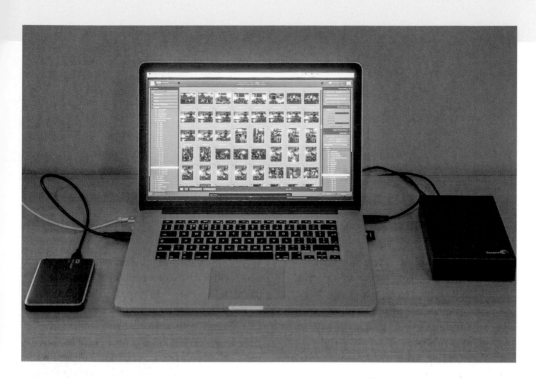

Backup, Always

Digital information is potentially easy to lose. You can overwrite files by mistake, you can delete by mistake (you can do all kinds of things by mistake), and very occasionally bad things happen to good computers and their drives. It's also easy to ignore the need to make copies and store them elsewhere—that's what a backup is—but all you need to do is to imagine how you would feel if you lost your images forever. Remember that you can say "but it never happened before" only once!

It's important to keep the backup images on a different machine from your computer in case of a crash, and the simplest method is separate, external hard drives. There is software to perform backups, and many computers have this option built in, but it's also simple to do it manually with a Copy command and Paste to your backup external hard drive. Make backups immediately; if you wait, you might forget.

Above: Backing up files already downloaded to a laptop onto two external drives for extra safety.

1. Download images from the camera or memory card to the computer's hard drive or connected standalone storage like a RAID or Drobo as soon as is practical.
2. Copy these onto a separate hard drive. These are your first backup.
3. Only delete images from the memory card (by reformatting) once you have both downloaded them and completed your backup.
4. For extra safety, make a second backup on a second separate hard drive, and keep this off site in a different physical location.

PROCESSING IS NOT PLAYTIME

If you shoot Raw, digital processing is as essential as printing a film negative was in a wet darkroom. It converts the image data recorded by your camera into the best possible viewable image.

In the professional way, you should not think of processing either as a boring duty or as a chance to play around. To be effective, processing needs to follow your shooting and the ideas you had at the time of shooting. It is not a creative activity, because creativity is inevitably concentrated on the moment of shooting, but it is a very important craft. It isn't compatible to try and be creative in two places, shooting and processing.

The main purpose of most processing is to do full justice to the Raw image file. This contains much more tonal information than can ever be reproduced in a print or on a normal screen, which is why the Raw processing stage is so important, particularly for "difficult" images, such as those with a very high dynamic range. For most images, the default is simply to optimize it, which means preparing a TIFF from the Raw file in a way that simply looks the way most viewers would expect it to look.

A step up from that is applying more skill and more techniques to really make the most of the image, in ways that may seem small to the casual viewer but which from a professional point of view enhance or reduce different areas and/or subjects within the frame. Each time you shoot, there's a reason and a motivation, and you can plan to process the image to make the best of that effect, whatever it is.

At a more advanced level, precision processing can solve problems, not just of mistakes made during shooting, but in very high contrast situations. Modern DSLRs and high-end mirrorless cameras now have very good dynamic ranges, but the real world can still produce situations that are beyond them.

Processing Software:

Adobe Lightroom
- designed for photographers
- blends an image database so you can sort and catalog your images
- has many of Photoshop's capabilities; both use the same Raw-processing engine, Adobe Camera Raw

Adobe Photoshop
- the original, powerful software that goes beyond photography to include all kinds of imaging
- does an excellent job with processing
- leaves organizing and databases to other programs

Phase One Capture One Pro
- adherents love its Raw processing algorithms; they pull out exceptional detail
- has image organization features (not quite as comprehensive as Lightroom's)

DXO Optics Pro
- excels at noise reduction and lens geometry corrections
- weak at workflow organization

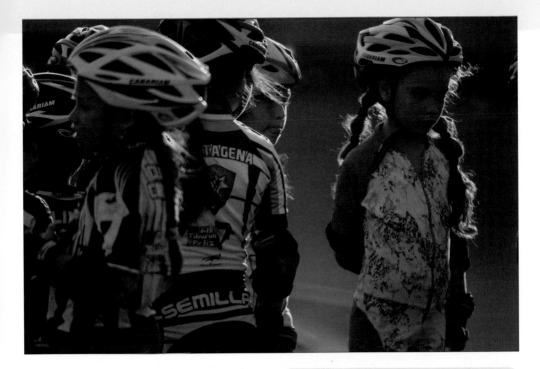

Optimization Walkthrough

Step 0 (Before Processing):
Once you've opened the Raw image, before making any adjustments, stop and consider two things:

- What had you expected or wanted when you shot the image, and how close does it look to this now?

- Looking at it objectively, as if a viewer coming fresh to the image without preconceptions, are its image qualities all as expected?

Sample Optimization:

- Apply lens profile and color fringing correction
- Use default sharpness. This shouldn't need touching; it corrects for the slight loss from the Raw conversion process.
- Adjust color so that neutrals (whites, grays, etc.) are indeed neutral.
- Exposure: Make an overall judgment on brightness; you can come back to this later
- Highlights, Shadows, and Contrast: Use moderate recovery as necessary, compensating for the flattening effect by raising Contrast.
- Set black and white points. This makes the image cover the full dynamic range.
- An alternative to Exposure and Contrast is to use Curves.

Step 1: Lens Profile

The software will detect the camera-lens combination, so checking this removes vignetting and geometric distortions, which are common with all zoom lenses. Adobe advises that their color correction, offered as a separate checkbox, is more effective at eliminating color fringing than the lens manufacturers' own profiles, so check this always.

Step 2: Default Sharpness

There are just two occasions for sharpening: 1. to compensate just a little for the slight softening that digital capture creates, and 2. a more aggressive one just before display (printing or screen display). Perform only #1 during Raw processing; the ACR defaults shown here are recommended—25%, radius 1 pixel, detail 25%, no masking.

Step 3: Global Adjustment

In preparation, make sure that the upper left and right triangles on the histogram are checked, so that clipped highlights appear red and clipped shadows appear blue. Also beware that the following sliders are effective at what they set out to do but carry the penalty of non-traditional appearance (i.e., tend to give an illustrative look rather than a traditional photographic look): Highlights, Shadows, and Clarity. These three use local tone-mapping algorithms.

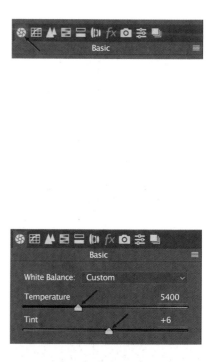

- Color: By default, aim for making obvious neutrals (such as gray metal or concrete) actually neutral (RGB values should be more or less equal to each other). If the light has an obvious cast, consider whether you want the final color to have a slight cast; this is up to your taste entirely. Color temperature is from blush to orange-ish, while the lower slider works the other color axis, from green to red.

• Exposure: Make an overall judgment. You can always go back to this later.

• Highlights/Shadows/Contrast: This is my preferred technique, but there are others (read on to learn about Curves). Reduce Highlights and raise Shadows by no more than 30 – 40% (any more and you risk a nonphotographic look). The effect of these two is to flatten the image, so raise Contrast accordingly (perhaps around 25%).

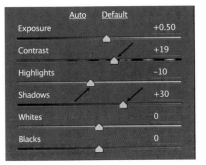

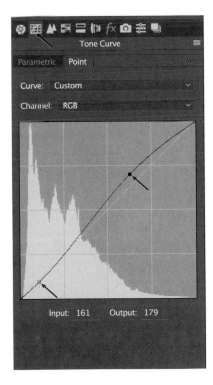

Alternatively, use Curves. This is very traditional and gives you control over highlights, shadows, and contrast all by changing the shape of a single curve, as shown, but using it effectively requires practice.

• Whites and Blacks: Also known as setting the black and white points, here you can raise or lower the Whites slider until just below the red warnings appear for clipped highlights. Lower (most likely, as it's hardly ever necessary to raise) the Blacks slider until just above the blue warnings.

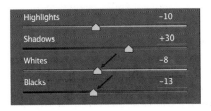

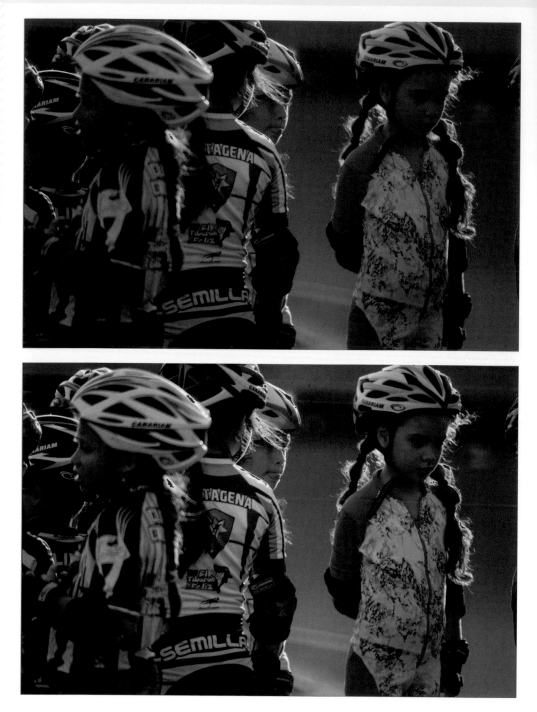

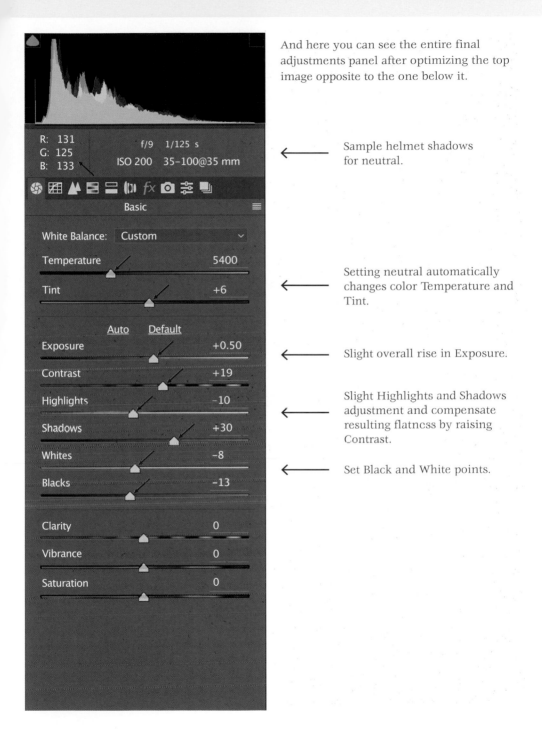

And here you can see the entire final adjustments panel after optimizing the top image opposite to the one below it.

Sample helmet shadows for neutral. ←

Setting neutral automatically changes color Temperature and Tint. ←

Slight overall rise in Exposure. ←

Slight Highlights and Shadows adjustment and compensate resulting flatness by raising Contrast. ←

Set Black and White points. ←

Focus Stacking

Here, just the sharpest parts of a scene
have been combined after photographing
the scene with the lens focused at different
distances. Helicon Focus is the most widely
used software and in its default settings is
virtually a one-click operation. But if your
deep scene is arranged smoothly in one
direction across the frame, as in this
example from top to bottom, you can do this
yourself in Photoshop. This scene was shot
in three frames with a fixed-aperture $f/8$
500mm lens, unable to manage the entire
depth of field in just one shot. The focus
was racked rapidly between the frames.
Stacked on top each other as layers in
Photoshop, it was a simple matter to
softly brush out the out-of-focus areas.

A Photographic Look

There's no established terminology
about this, but the processed "look" of a
photograph is a new phenomenon since
the invention of digital ways of handling
brightness and contrast on a local scale. In
film-based photography, it had no meaning
because all film and photographic paper
responded in essentially the same way to
exposure and processing. Photographs
had a consistent look. Digital algorithmic
processing of Raw files has changed this.

In Adobe Camera Raw, which is shared
by Photoshop and Lightroom, three sliders
in particular work on the entire image but
in a local way: Highlights, Shadows, and
Clarity. They use TMOs (Tone Mapping
Operators) that alter brightness by means
of very localized contrast. Essentially, they
search around their pixel neighborhood and
make adjustments based on neighboring
pixels. The results are powerful in that they
can "open up" shadow areas (any areas, in
fact) with increased localized contrast and
crispness, but applied strongly they produce
an effect that is hyper-detailed—more like
an Andrew Wyeth painting, for example.

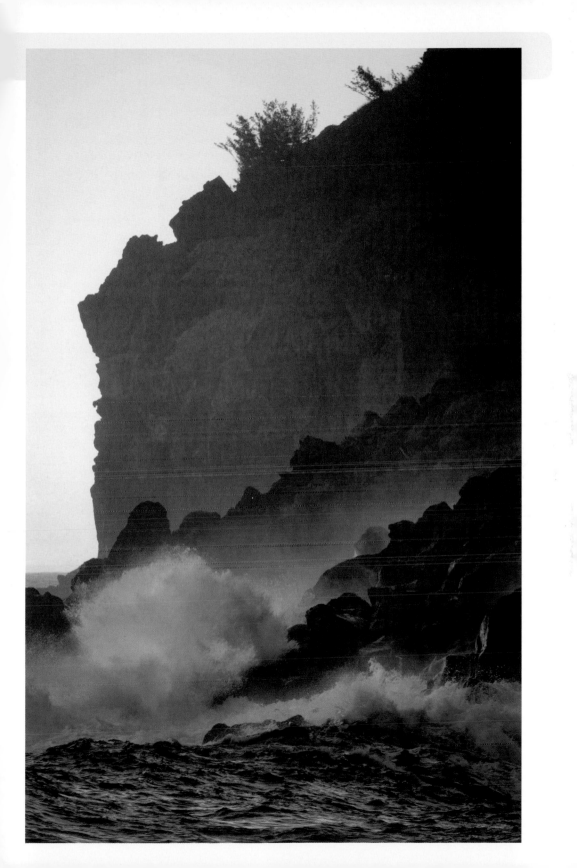

Global, Local, or Both?

Processing tools can be applied to the entire image (that is, global) or to selected areas (local). The attraction of global processing is that it seems at face value to be neater and simpler, and is certainly quicker. It lends itself to batch processing (treating a group of images al the same way) and if that's your style of shooting, it's a real advantage. The arguments for local processing are first that this is a precision approach, and second that you can stick to traditional tools that will better preserve a natural photographic look. In any case, local processing is almost always performed on top of a relatively simple base-level global setting.

Simply put, if you have the time and are concerned about refining the processing to bring out the very best in the image, first make a base setting for the entire image that looks good overall with the exception of some specific areas. Then use local adjustment (such as a radial filter) for one, two, or many specific areas, tailoring the settings just for that. Local adjustment in most software allows you to access virtually all of the processing tools available for global.

This way you can target with great precision areas where you may want to lighten, darken, change the contrast, color, saturation, and anything else. Moreover, you can temper the use of those algorithmic TMOs for your base global settings and stay in control of "the look." This is precision processing and can handle almost any high dynamic range situation, at least within the capacity of your camera's sensor. For anyone with a passing interest in old-fashioned, wet-darkroom printing, this was how skilled prints used to be made, though the clock was running and extreme precision wasn't quite possible.

The downside is that it takes time and even some skill, but really, if you're shooting for yourself and don't have to produce a large number of images quickly for a client, a good image deserves time being spent on it. The tools to use depend on personal preference, but a radial filter has a lot going for it because if you get the degree of feathering right, the adjustment effect ramps smoothly and imperceptibly.

Below & opposite: A straightforward example of necessary local adjustment. At left, as globally processed, the man's face is too dark. A radial filter, with moderate feathering, allows brightness to be increased subtly.

HDR FOR ADULTS

High Dynamic Range (HDR) imaging was invented to archive light, but was unfortunately hijacked early on by idiots to create lurid imagery that has little to do with photography.

Here's what it's really for: skillfully handling scenes that span a large range of light without getting overexcited. The HDR part of the process simply involves shooting a series of identical frames with different exposures, sufficient to capture everything from the brightest highlight to the deepest shadow, typically 2 f/stops apart. Software then combines them into a single image file.

What many people and manufacturers lazily call HDR style isn't that at all. This over-processed style of revealing every tone in the scene and then some comes from the tone-mapping part of the equation—algorithms that compress the huge range of light into a viewable form on a screen or in a print. You have an image file that contains everything, but your screen or printing paper can show just a fraction of it, unlike our eyes, which can take in any amount of dynamic range. There has to be a compromise, and in professional work that means working within traditional photographic values and keeping a "photographic look."

There are many ways of processing HDR, but making a 32-bit, floating-point TIFF file and then processing it with local adjustments is solid and reliable. The example here uses Photoshop, which offers the 32-bit option and continuing in ACR (Adobe Camera Raw, the normal Raw processing engine) with a single click. The experience is notably different from using ACR on a single Raw file because it's as if you had captured the scene with a super sensor. The Highlights and Shadows sliders can be pushed almost to extremes without the typical tone-mapped look just described, while local adjustment, such as with radial filters, works incredibly powerfully. The secret is to hold all this processing power in check by moderating to your own taste.

Right: The first step is to load the range of exposures into an HDR program and create a 32-bit-per-channel TIFF (top). This is how it appears when opened in ACR before processing (center). The next step (bottom) is to shift Highlights to extreme left to recover the brightest areas in the HDR image file.

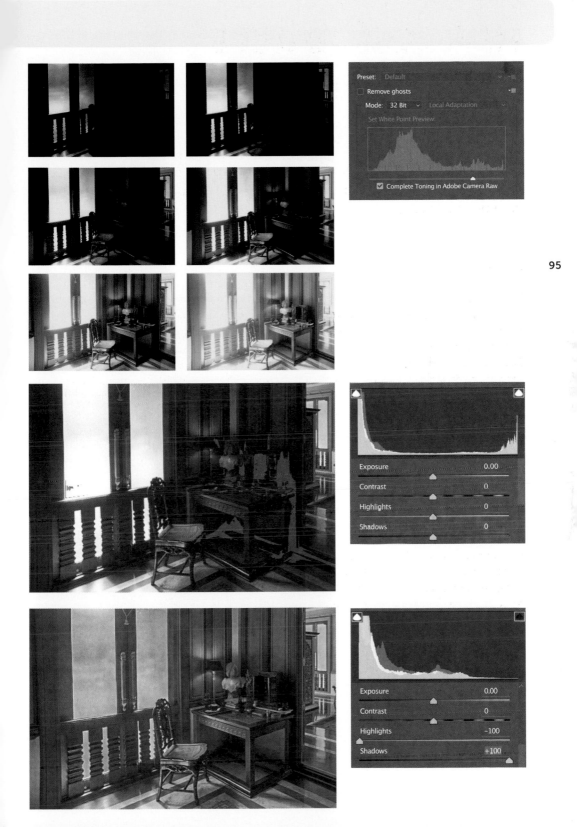

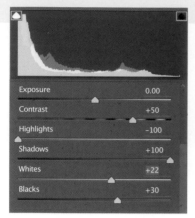

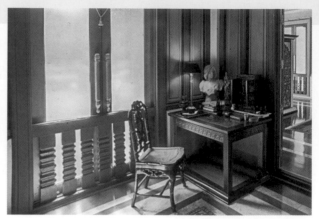

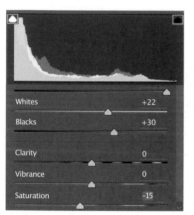

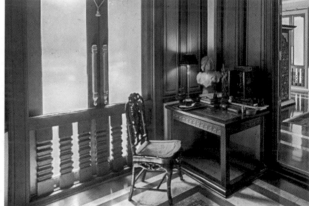

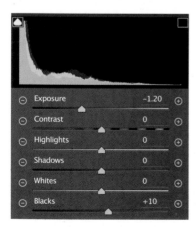

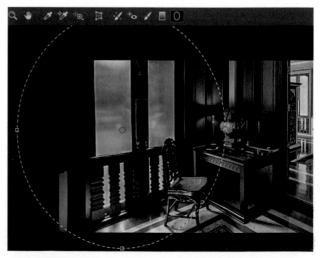

Opposite: Shadows are then shifted to extreme right, and to compensate for the flattening effect of the Highlights and Shadows sliders on the mid-tones, Contrast is raised (top). Also, some small adjustment to set the Black and White points. HDR images tend to exaggerate Saturation, so this is next reduced (center). Finally (bottom), local adjustments can be used to brighten or darken different smaller areas and fine-tune the image.

Below:

The finished image manages to include a huge range—a Thai interior with dark panelling shot entirely in natural light on a very bright tropical day—and yet retain a photographic look.

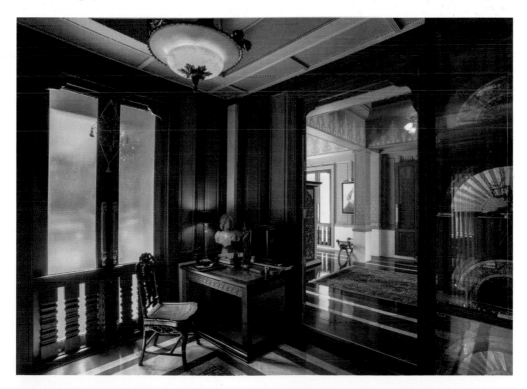

What Makes a Good Photograph?

It's a universal question, but without a single agreed-upon answer. In fact, the same goes for art in general. Poet, philosopher, and general polymath J. W. von Goethe suggested three questions to be asked about any work of art, and they're as relevant (and tough) about photography as about older creative forms:

1. What was the artist trying to do?
2. How well did he [or she] do it?
3. Was it worth the doing?

This is quite a brutal way of looking at a photograph, but necessary. It's very much about success or failure, suggesting that photographs should start with some kind of intention rather than just thoughtlessly snapping away, and that they require some skill and effort in order to work well.

Judging a Photograph

People who do this professionally—like picture editors for publications, curators, and judges of photo competitions—have different procedures, and even different priorities, but the following eight points are not far off the mark. The first four have to do with visual appearance; the second four are about content. Not all elements are expected to be strong at the same time and in the same picture, however. For example, a photograph can be strikingly good on purely visual grounds without an important subject. Also, not every good photograph needs to be clear and "readable;" it could be deliberately ambiguous.

1. Is It Eye-Catching?: This is one of the most important qualities and is overwhelmingly visual. It means a lot more than just being dramatic; an image may not necessarily be dramatic at all in the conventional sense, as it could involve extreme simplicity. The first duty of a picture, however, is to catch the eye.

2. Is It Imaginative?: Did the photographer use imagination and go a step further, beyond the obvious? Did he or she try out some new angle, make an intriguing visual comparison, or use unusual lighting? Above all, is it different from everyone else's? If it looks exactly the same as a hundred other pictures (which often happens with well-known specific viewpoints), it has very little value.

3. Does It Have a Distinct Style?: This is one of the lodestones of creative photography, and it isn't very common, so by no means is it expected. If a photographer has developed a special way of making images that is distinctly different or even unique, that's a very strong advantage in terms of perceived quality.

4. How Well Does It "Read?": This mainly has to do with the skill of putting an image together so that it gets across the point that the photographer intends. For a very clear subject, like a wildlife behavioral shot, it should be visually very clear and readable. Or, for example, if the subject is intentionally a silhouette, then the outline should be clear and well outlined against a contrasting background. On the other hand, if the photograph is intended to be mysterious and ambiguous, the visual treatment needs to maintain that mystery.

5. Is the Subject Important, Interesting, and Engaging?: You can make successful photographs of unimportant throwaway subjects, so this is not a necessity for success. However, if the subject is different, engaging, fascinating, and/or well observed, that does give the image extra value points.

6. Did the Photographer Make a Clear Effort?: More award points go to photographers who obviously went to extra effort and trouble to get access to the place or to the subject, and who clearly worked at getting the shot.

2

IMAGE

7. Does It Have Emotional Impact?: This is difficult to predict, but if the image has heart and soul—or at least touches the heart and soul of the viewer—then it has an extra, powerful dimension.

8. Is There an Idea Behind the Picture?: Often sheer thoughtfulness can help a picture be selected. Has the photographer put some intelligence and thought into the image? Does it convey an idea, perhaps by the viewpoint or the moment, or by juxtaposing two elements that the viewer hadn't considered before?

THE INGREDIENTS OF A PHOTOGRAPH

Not everyone agrees that it's worth trying to judge how good a photograph is, as it introduces a competitive edge that the enjoyment of photography doesn't need.

It might be more useful, or more practical, to ask what goes into the success of a photograph—in other words, the ingredients. Although you could break them down into more, the following eight items cover the bases. It's rare that all are equal, and the proportions of each will vary from one picture to the next.

1. Subject: This refers to the content of the image—what it's about—and can vary from being the only important thing (as in much news photography) to being irrelevant (as in abstract impressionistic photography).

2. Composition: Composition is arguably the most important ingredient that the photographer can control. It's about creating order out of chaos and making an image in which the elements—like shapes and lines—visually fit together. Composition also needs to maintain interest, and originality is valued over following any perceived "rules."

3. Viewpoint: In some ways a part of composition, viewpoint is related to where you choose to stand. It affects how elements in the frame relate to each other from your point of view, regardless of how they do or don't in real life.

4. Moment: Timing can be crucial to an image. Capturing one particular moment rather than any other is fundamental to what photography is all about: a slice out of time.

5. Light: The quality of light often makes or breaks a photograph, particularly when the aim is to be attractive and striking, whether it's a rare occasion of special light from nature or skillfully constructed lighting in the studio.

6. Color: Just as light can work almost as a commodity in imagery, so can color but even more viscerally. Color triggers an emotional response in a way that other visual qualities don't. And remember, black and white are colors, too; you can make an emotional impact in gray tones, as well.

7. Processing: Normally, processing is an adjunct to photography's creative processes and is considered as a valuable craft and skill. It can, however, contribute greatly to the success of the final photograph, particularly when the lighting was difficult or when you need to emphasize some parts of the image.

8. Equipment: Despite the marketing by manufacturers and regardless of camera enthusiasts' preference for equipment over imagination, it is not normally the main ingredient of an image. Nevertheless, there are occasions when equipment counts, such as with long telephotos for wildlife and sports or tilt-shift and other specialist lenses with particular optical effects.

This page: These are the basic eight ingredients that go into any photograph, but with very different proportions. The photograph above of a girl fishing in Surinam depends very much for its success on the light, but hardly at all on processing or even color. By contrast, the large-format picture of the Bank of England in London depends especially on precise composition and precise viewpoint, but very little, for example, on moment.

FRAMING

For many, framing a shot and composing it are part of the same operation, but I'm splitting them (and hopefully not hairs) because the first comes fractionally before the second.

Framing refers to the way in which you enclose the scene within the rectangle—what you choose to include and what you leave out—and there are times when that's a more basic decision than how you then arrange the things you've selected. In any case, it's very much a part of the core of personal photography because it's as much about keeping out the rest of the world in front of you as it is about picking your subject.

Photography isn't just about choosing which slice of time to capture; it also means choosing which rectangle of space. Moving the rectangle of your viewfinder over the scene is the primary decision, even if you do that mentally before you actually move the camera. With time on your hands, you can consider and reflect, but in fluid situations that involve movement and people, you may have to decide in less than a second, and that's too short a time to do any conscious thinking. That's why it's important to train yourself to shoot intuitively, which you can accomplish through constant practice.

When you buy a camera, you buy the camera format, 3:2 and 4:3 being the two most common formats. You can choose

to shoot loosely with the idea of cropping later, but that's a bit sloppy and indecisive. It's generally more satisfying and skillful to compose images exactly within the frame you're given. Pay close attention to what's going on near the borders of the frame because these elements will attract attention. You can cut through anything you like, and align or even misalign an edge with something in the scene, but make sure that it's deliberate and for a reason.

Frame Shape

Picture proportions in photography are the way they are because of inertia and occasional invention. The DSLR frame shape is 3:2 because it inherited the format of the original SLRs, which used 35mm film. That in turn was invented in the 1920s by Leica to make maximum use of the then newly invented "sprocketed" motion picture film. The fatter 4:3 format, also known as Four Thirds, makes better use of the lens coverage, which was a main reason for its invention in 2003. Even so, in many ways it's a more traditional image format than 3:2, being close to Academy ratio (the early motion picture format), the standard

printing paper 10 x 8-inch format, and the studio sheet film formats 10 x 8 and 5 x 4. 16:9 widescreen was invented in the 1980s as a compromise that could accommodate all the then different television formats.

In other words, the reasons for these formats had little to do with composition, but once set, photographers learned how to work happily within them. Most of us treat the frame as a given and adjust our compositions to fit it exactly. Some insist on no cropping and no extending as a proof of purity and skill, while others take a more lenient view, that the frame should be sympathetic to the subject and the way the photographer feels like composing.

Above: A wide-angle view of a Thai rice field with an old temple, and within it four other, tighter ways of framing the scene that would work photographically.

COMPOSING

Arguably the most important operation in photography has absolutely nothing to do with equipment. It has much more to do with what goes on inside the photographer's head, specifically what you see and how you see it.

Order Out of Chaos

What makes photography different from all other creative activities (and why composition is so important in establishing your own style) is that the starting point is actually a fully formed image. Even without making any effort at all, you have a photograph that's fairly well exposed and focused. There's no blank canvas, blank score sheet, or blank manuscript.

So, if without even thinking, anyone can produce a technically acceptable image, what's going to make the difference? What's going to make a photograph worth a second glance? More than anything, the difference has to come from what you choose to show from the messy world in front of the camera and how you arrange it in the frame. That

Above & right: The columns of London's Royal Exchange are the setting, but the actual composition depended on timing, for both passersby and the red bus.

means bringing some kind of order to whatever unstructured scene there is. By "order," I don't necessarily mean precise and geometric, although that's certainly one way of composing an image; in this context, order simply refers to the act of imposing your visual sense on the scene. There are infinite ways of doing this, from being minimalist all the way to being dramatic and complicated, but all of them are about making an image that's visually interesting and, as much as possible, different from what a viewer would expect.

This is why there really are no rules in being creative. The moment composition becomes predictable, which is what rules of any kind are designed to do, you lose a large amount of the viewer's attention. If there's one thing that almost counts as a rule in composition, it's: Don't be boring.

Balance & Imbalance

Visually, most of us are naturally attuned to the idea of balance, just as we are to things being lopsided. Generally, the thought of balance is satisfying and comfortable. It's a part of human nature to want things to be in order (which harkens back to the previous pages). The simplest example is having two objects, colors, or graphic elements in a picture balanced on either side of the frame yet, as you might expect, it's hardly as simple as that. While the eye might search for balance, just having it perfectly presented isn't a guarantee of satisfaction. Perfectly balanced anything isn't particularly interesting, but the process of trying to balance or playing with balance certainly can be.

A simple but effective analogy for balance between two things or areas is a seesaw balanced on a fulcrum. Two things of equal importance or weight balance each other when they're evenly spaced apart, but when one is heavier or stronger than the other, it balances when it's closer to the center and the smaller one further away. Balance, in other words, can be dynamic, and given how many ingredients are competing in a photograph for attention (see page 56), the arrangement of parts can be subtle and complex. A simple situation, such as two people in conversation and dominating the frame (a two-shot, in other words), is a lot less common than busier scenes with more parts, and some of these elements will have more visual "weight" than others. Any human face, for example, will pull attention.

On top of this, imbalance can be much more interesting because it sets up unresolved tensions. Actually satisfying a visual need is no guarantee of effective composition and no guarantee of making a compelling image, either. It's interesting how people look at an imbalanced, lopsided

Above: At first, the placement of the red Chinese flag at the far right seems extreme, but the eye makes sense of it by recognizing the contrast of color and light between this and the traditional roofs of an old Chinese town. The two elements, (massed rooftops and single bright flag) balance each other in a less-than-predictable way.

Opposite: Two vectors balance this image by pulling apart—the eyeline of the man and the rightward direction of the flow of molten steel in a bell foundry. Like the image above, the balance is dynamic rather than static.

picture like the one here. Our eyes and brain work harder to try and find a balance of some sort, so images like these can, in fact, engage more attention.

Coincidence & Coinciding

Outside the studio, you have very little control over what goes on, and that's what makes finding a visual connection between things a particularly strong feature in photography. Connection runs the whole range from a simple alignment with the edge of the frame to a juxtaposition between subjects that in reality have nothing to do with each other besides the way you saw them from one viewpoint.

Coincidence, if you think about it, is right at the heart of much successful photography. It's a correspondence between two or more things that's unexpected. It might be two subjects that you wouldn't normally think would go together, or it might be some graphic connection. In whatever case, photographically it depends on you seeing what most other people wouldn't. And that, purely and simply, makes your own eye and imagination stand apart from other people's.

Juxtaposition, as in the image below, is the classic photographic coincidence, because it takes observation, imagination, and skill to find and capture it. It wouldn't work if you could arrange it; it really has to be snatched from real life and be unintentional. This very much depends on the way you see, your viewpoint, and your lens's focal length. Juxtaposition works with subjects as varied as people's expressions, gestures, actions, and unrelated objects that appear to join with them from the camera's view. It also works with what I call a "graphic echo." This usually involves either shape or color, and sometimes by both. There are no hard-and-fast rules for this kind of correspondence, but if you attune your eye to spot them, consciously looking for them, you may be surprised how often they appear. In either case, it helps if they are clear and simple. Shapes that are distinctive and recognizable do well, such as

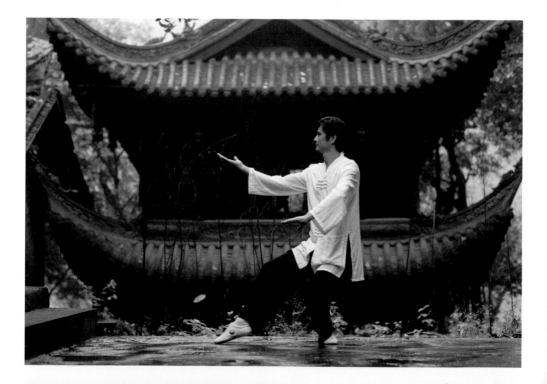

Left & above: The moment chosen here, of the Mekong River at Vientiane, deliberately creates symmetry as the figure of the boy coincides with the pillar-like reflection of the setting sun, precisely centered in the frame.

Opposite & left: Another kind of coincidence is the graphic echo between unrelated subjects in the same frame. In this case it is the arm position of a kungfu master which echoes the roof lines of the temple building behind.

Top: The waiter at an Art Nouveau café in Paris echoes the figure on the tiled wall, made the more obvious by positioning the two figures at ether edge of the frame

Bottom: Waiting for the moment when these three Indian farmers winnowing coincided in their action gave a completeness to the image.

a triangle (although triangles tend to be so common that their coincidence value isn't that high).

Ultimately, coincidence of all kinds play a much larger role in photography than it might seem at first because it ranges from being striking all the way down to smaller, subtler alignments. You could say that any kind of thoughtful and neat composition and framing is about making things coincide. After all, lining things up when you frame a shot is one of the most basic decisions in composition—so basic that many of us who take the trouble to align things in the frame do it semi-automatically. The things being lined up can be edges (like the walls of a building) or a row of things (like cows in a field); it's ultimately very personal. For some photographers it's simply a sign of neatness while for others it becomes the justification for shooting, but in no way is it a rule.

Generally speaking, you can line two or more things up by repositioning yourself so they look as if they fit, or you can line things up with the edges of your frame. You might actually be able to do both at once. It can even justify a tilted camera. Garry Winogrand was known for tilting his camera this way and that, but delighted in telling people, "[T]hey're not tilted, you see. … I never do it without a reason. … I have a picture of a beggar, where there's an arm coming into the frame from the side. And the arm is parallel to the horizontal edge and it makes it work." All of it draws on the fact that the graphic elements in any photograph—the arrangement of lines and shapes and how definite they appear—are in one sense a separate matter from the actual real subjects and their setting. Those in the audience get a form of satisfaction from seeing elements lining up that they might not have expected to.

Eight Kinds of Alignment

Lining things up, whether with each other or with the edges of the frame, is one kind of coincidence. Even if it's not utterly surprising, it's still a satisfying skill. Try any of these:

1. Lines to frame edges
2. Lines to frame corners
3. Frames within the frame
4. Neat fit
5. Elements in a row
6. Elements repeat
7. Rhythm
8. Elements make a shape

Deep or Flat

How much sense a photograph gives of the three-dimensionality of a scene is very much down to the way you treat it with composition and lens, and it can go all the way from a striking sense of depth from foreground to background to deliberately flattening a scene so that it looks two-dimensional. Both extremes can be distinctive and strong, and both deal in different kinds of perspective, either enhancing or suppressing. Linear and diminishing perspective are usually the strongest kinds, featuring converging lines and reducing scale. The keys to handling these two types of perspective are viewpoint and lens focal length. Aerial perspective involves haze, which you can enhance or suppress through shooting techniques as well as filters and digital processing. Tonal and color perspective are less prominent but can still be added for extra effect.

Focus plays a special role in managing the sense of depth because, while we take it for granted in daily life that everything in sight appears sharp, an out-of-focus foreground or background in a photograph is an instant reminder of depth. With a long-focus lens this is so usual that stopping down to the minimum aperture (like $f/22$) for full sharpness strongly confounds the sense of depth. With a wide-angle lens, however, strong depth of field by stopping down can actually work with other strategies, particularly setting a strong foreground against the background. Ansel Adams, a master of this technique with landscape, called it the "Near-Far" approach. Sharpness that covers such a range heightens the sense of reality.

Below: The equal lighting from behind the camera in late afternoon, and the equal sharpness from a small aperture, combine to flatten the sense of this image, despite the ultrawide 20mm focal length.

Deepening Strategies

- Distinct foreground against background
- Continuous flow from foreground to background
- Lines converge on distance (linear perspective)
- Wide-angle lens to enhance the above
- Similar or identical objects get smaller with distance (diminishing perspective)
- Hazy conditions (aerial perspective)
- Shoot toward the light in haze
- Black-and-white process strong in blue and cyan to enhance aerial perspective
- Light subject against darker background (tonal perspective)
- Warm colors in front of cool colors (color perspective)
- Foreground or background out of focus

Flattening Strategies

- Face-on viewpoint and squared-up composition
- Few or no diagonals
- Disconnect different planes of distance from each other
- Long focal length to enhance the above
- Choose viewpoint to reduce distance clues of familiar objects
- Clear atmosphere with no haze
- Reduce haze with UV or polarizing filter
- Digital de-hazing
- Strong axial lighting (from behind camera)
- Darker subject against lighter background
- Cool colors in front of warm colors
- Full depth of field, all sharp

Top: A wide-angle lens, a viewpoint that exaggerates diagonal perspective, and shooting from shade toward light together create a strong sense of three dimensions.

Bottom: The almost-square window frame looking onto a Japanese interior garden, and flat lighting give a two-dimensional sense to this shot.

Directing the Eye

One of the basic jobs of composition is to try and influence how people look at your image. Do they start in one part of the frame and then move over somewhere else, or does their eye just wander aimlessly? Or do they just stare? It's not always easy to have much influence, but it's possible, and the more control you have over the way a viewer takes in your photograph, the more interesting you can make the composition.

First, certain subjects tend to grab attention more than others; they have more visual weight. The most common high-attracting subject is the human face, and within it, the eyes and mouth. Size for size in the frame, a human face will usually pull the eye more strongly than other things, and that means you can compose a shot with a face small in the frame, and also way off center, and still be confident that the viewer's eye will end up there. Other subjects that have strong visual weight are the human figure, animals, words, and numbers.

Lines of various kinds can pull attention along them because we see them as having a direction and they encourage the eye to follow. By nature, the eye and brain are always trying to find simple graphic structures in what we look at, "connecting the dots" so to speak. The angle of the line plays an important role and—in terms of energy, noticeability, and sense of movement—the strongest is the diagonal. For instance, a definite diagonal with one end close to a corner and the other near the center will almost always help to take the eye inward. Converging diagonals lead the eye even more definitely.

By default, the eye tends to drift toward the center when looking at a photograph rather than outward, although you can reverse this by where you place subjects with strong visual weight, or by using the third major eye-leading technique: the direction in which subjects are facing.

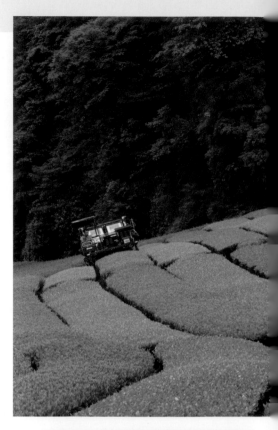

People in photographs are almost always seen as facing in one direction or another, and this creates a sense of direction. If the figures are actively looking in one direction, they create what is known as an eye-line, which can pull the viewer's eye strongly.

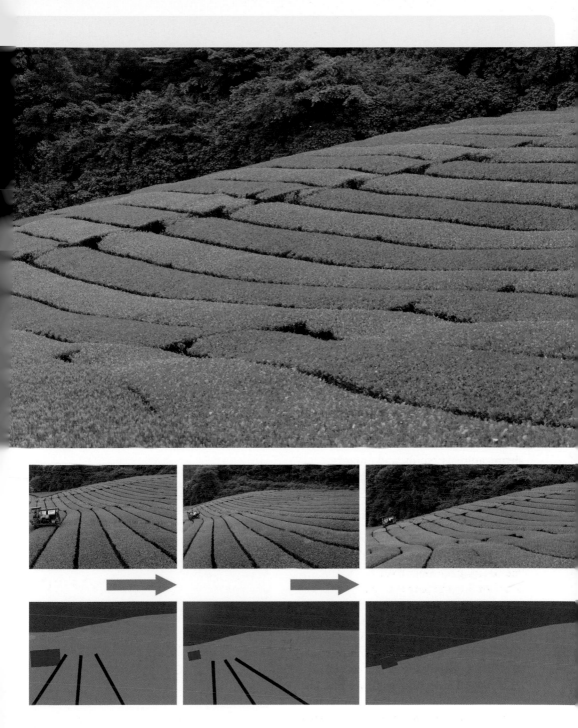

Above: The sequence of smaller images left to right show the photographer's process of attempting to simplify this tea-garden scene in Japan, making us of both converging lines and an eccentrically placed spot color to manipulate the viewer's eye.

It's In The Details

Changing the scale of what we pay attention to reveals another world with different visual possibilities. Why do we love details? Among photographers, it's almost a universal love, and even landscape specialists find themselves drawn every so often into the close-focused worlds that sit within their expansive big subjects. Ansel Adams was as happy with a bark detail or rock surface as he was with El Capitan or Half Dome. In his famous book Yosemite and the Range of Light, more than a fifth of the photographs are actually of details. One reason, as any picture editor knows, is that variety is the key to a series of images, and variety of scale is an obvious way to create this.

Details of things can stand in for a bigger subject. Diane Arbus said, "The more specific you are, the more general it'll be." In other words, a well-chosen and captured detail image can expand in the viewer's mind to be more universal. Detail always hints at something larger. For instance, when photographing people, details of the human body always fascinate, all the more so because the viewer is invited to imagine the person from just one part. One of the easiest-to-find yet richest sources of photographable detail is the human body. Even without getting rude (that's another area of shooting that we probably won't be dealing with in this series), there are several specific bits that can be intriguing and photogenic. Chief among them are hands, lips, eyes, fingers, and nails, and I suppose the growing popularity of tattoos makes them a worthy detail as well. For lips, just think of Erwin Blumenfeld's 1950 Vogue cover and Irving Penn's "Bee Stung Lips" (literally, with a bee on a plump, lipstick-covered, half-open sexy mouth). For eyes, there's Man Ray's image "Tears" from the 1930s, and what about the yellow-out-of-blue Na'vi eye from the poster for James Cameron's Avatar?

Another appeal is that the world of detail offers many more opportunities for fresh images than do the bigger scenes that everyone can see. One of the less satisfying aspects of photographing dramatic landscapes is that the "perfect" viewpoints are well known, and at any good shooting time, the viewpoints for Angkor Wat, Delicate Arch, China's Yuanyang Rice Terraces, or you-name-it-popular-destination are crowded and everyone gets the same image. Digging around for detail, however, is always rewarding. Exploring can reveal some unexpectedly beautiful and/or graphic images, almost regardless of the messiness, ugliness, or obviousness of the surroundings of which they're a part.

Below: Rose harvest in Bulgaria summarized in a close shot of a single rose held in a picker's hand against her protective dark red clothing.

Left: The hands and feet of two Afghan men resting in the heat of the day. Body parts can be more eloquent than the entire figure.

Left: A covering of moss and a sprouting small plant on the arm of a carved figure on the wall of an Angkor temple communicate the sense of overgrown abandon better than could the entire ruin.

Left: Hands at work can be particularly expressive, because, as in the playing of this traditional Chinese stringed instrument, all of the person's energy and concentration is channeled through them.

VIEWPOINT

It seems so obvious. Viewpoint is just where you stand to shoot. Many people don't give it a second thought. It's where they are, so that's the view, so shoot or not according to whether it's worth it or not.

A different way of thinking, though, is that here's a potential shot (or even here's a shot I need to take); is there a better angle? What could I make of this if I could see it from somewhere else? Maybe a step to one side? Maybe from somewhere radically different, like overhead or underneath or from over there? This kind of thinking is based on needing or wanting to get the shot somehow and it is—perhaps not surprisingly—standard procedure for professionals, who usually have a defined subject but not necessarily the best conditions.

Austrian-born photographer Ernst Haas said, "The most important lens you have is your legs." This was admittedly in the days before good zoom lenses, but the point he made was to work at finding the best

possible shot by investigating different viewpoints—not just closer or further as a more active substitute for changing focal length, but up, down, sideways, from over there, from anywhere imaginable that would improve the shot... or make it work in the first place! As we've just seen on the previous several pages, many images depend on very precise relationships in the frame between visual elements. The entire matter of alignments and juxtapositions are controlled by the exact camera position.

There are the broad strokes of viewpoint, and then there are the precise shifts. By far the vast majority of photographs are taken from just under two meters above the ground—head height for a standing person—and this is so normal as to be unremarked.

Left: Shooting from the top of a strikingly tall 19th-century lighthouse on a remote Indonesian island proved an effective viewpoint because it made use of the dramatic view while still showing the lighthouse through its shadow.

Even within this, though, there are all the possibilities of circling a subject, moving in, and moving back, but if you're looking for more clarity or simply being different, there's the possibility of elevation (going higher or lower). Shooting from above has always fascinated photographers because it's a kind of freedom from gravity. It's little wonder that drones have taken off, so to speak, in such a big way. A slightly more interesting advantage than just being above is the opportunity to make graphic shapes from overhead. Looking up from below is less common, and for that reason potentially more interesting. Increasing use of glass and open structure in contemporary architecture (see pages 174–177) is just one way of exploring this possibility.

Left: One extreme of viewpoint is overhead looking vertically down, not common except in aerial photographs.

Below: Looking upward from below is an equally unusual opportunity, and for that reason worth exploiting.

MOMENT

Whenever there's movement, there will be one or two moments for capturing it that will appeal more strongly to you than others. Decisive moments, in the inescapable term coined by Henri Cartier-Bresson, are the special ones that seem to encapsulate what the action was all about.

They're not fixed and objective, however, but depend on a mixture of three things:

1. What Is Actually Happening: Some actions have very definite climaxes or still-points, such as a soccer player scoring a goal.
2. What It Looks Like from the Camera's Viewpoint: As we just saw on the previous pages, viewpoint can create very different alignments and juxtapositions.
3. What Moment Do You Prefer: What moment—which frame—do you personally like? My choice won't necessarily be yours, so taste definitely plays a part.

Just about everything in photography calls for a decision about exactly when to shoot. Sometimes, it may seem to be less of a priority than other concerns like the framing or lighting, but a photograph is always of one moment, whatever it is. If your special photographic interest is one that regularly has things happening quickly—such as wildlife, sports, or street shooting—you'll likely be specially attuned to this already, but it also applies to most other subjects. With action, the moment of shooting is nearly always unique. Very few situations in front of the camera are ever repeated exactly. Finding the ideal moment—your ideal moment—takes some thought, practice and, above all, judgment. There's no formula for timing a shot.

Photographers approach the whole idea of capturing a best moment in different ways, but they tend to fall into three camps. I call them Marksman, Fireman, and Builder, and there are personality differences between them.

The Marksman approach is to get the action in one ideal shot—without a doubt the most skillful and traditional approach, coming from a world where film was in finite supply and no one wanted to waste it. Simple economy, however, was not really the driving force, but rather the pride in an ability to catch one "perfect" moment in one shot. There are many situations where getting it right in one shot is the only way, because what happens is over in a flash— very typical of street photography.

Above: Fast reaction and a trained eye for instant composition give this unexpected moment (not performed for the photographer's benefit) the slightly surreal feeling that many good street photographs have.

It's the Speed Across the Frame That Counts

The actual speed of a subject is less important than how fast it travels inside the frame, which sounds obvious, but it's easy to be over-impressed by actual high speed, such as from a racing car, as it is to underestimate the speed in the frame of a hand movement. A rule of thumb is if something takes a second to cross the frame, you'll need a shutter speed of 1/500 second to be safe in freezing its movement.

- A moving subject travels more slowly through the frame with a wide-angle lens than with a telephoto, which magnifies movement as well as other things.
- Something traveling smoothly, such as a vehicle on a road, moves fastest through the frame when it's going at right angles to you, much less when diagonally toward you, and hardly at all when coming straight at you (though there are still focus issues).
- Parts of subjects can move much faster than you might expect inside the frame, for instance a hand gesture from someone talking.
- Panning slows down the in-frame movement of a smoothly traveling subject, but not necessarily its moving parts (such as a cyclist's feet and legs).

The Fireman approach "hoses" the action by shooting as many frames as possible in the time that the action takes place. It's what the C for continuous shooting on a DSLR is for. By shooting around 10 frames a second, the argument runs that one of them will be fine when you edit them later.

The Builder approach also means shooting plenty of frames, but for a different purpose: improvement. When there's time and a repetitive action, it's virtually a duty to work on the situation to get the best moment. Typically, you start by shooting a few frames until you get the rhythm of the action and at least one reasonable shot, then stay with the situation and shoot just when you think it's a bit better. You continue, shooting fewer frames more and more discriminately.

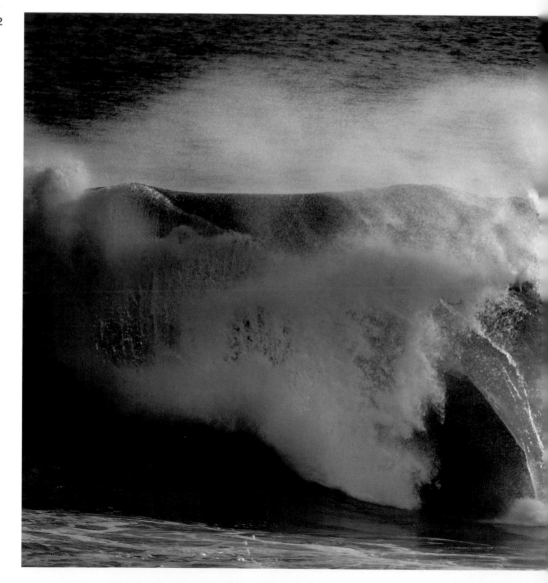

Below: A high shutter speed (1/500 second) is a given for shooting waves like this, but what gives the image is strength is the precise moment as the forward edge pours downward, backlit and turquoise, with a feeling of solidity.

Urgency, Precision, and Speed

Moments have three basic qualities and they vary in importance according to what the action is about. Urgency means how quickly the moment comes at you, and can vary from really urgent in street photography to plenty of time waiting for a sunset. Precision is about getting just the perfect cusp of an action or fitting a passing figure into just that space in the frame. Speed is self-explanatory, but you need some experience and good judgment to know exactly what shutter speed you'll need to do the job.

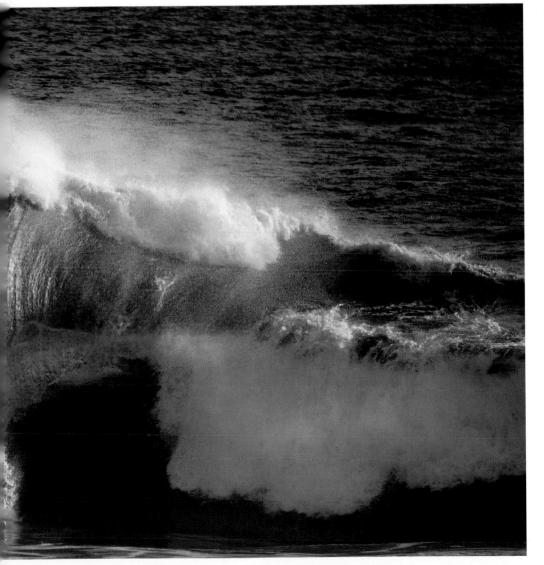

LIGHT QUALITY

It's almost a cliché of photography that the quality of light can make or break a shot, but it also happens to be true. Unless you have a subject in front of you that's so amazing it wouldn't matter what light it was shot in, the one thing you can usually do to improve a photograph is to make sure it's attractively or excitingly lit.

Unless you have a subject in front of you that's so amazing it wouldn't matter what light it was shot in, the one thing you can usually do to improve a photograph is to make sure it's attractively or excitingly lit. That in turn means having a feeling for lighting, a conscious appreciation of it, and developing that sensibility to the point where you know why the lighting is the way it is. In other words, you need to grasp not only the magic of light but the logic behind it as well.

Going back to the ingredients of a photograph on page 100, light has a scale of importance that at the lower end is unremarkable, but at certain times of day, in some weather, and in certain configurations of street and buildings, it starts to take over. Light then imposes itself on the scene and on the image. At the very top end of the scale, the shot is all about the light effects, and they become much more important than the physical subject.

There are basically two ways of working with light in shooting. One is to have an idea of what lighting might best suit your subject, then wait it out or return another time when you anticipate that you'll get that light. The other is to shift gears and look for subjects and compositions that will make the most of the light you're already under. An example of the first was a street shot by Australian photographer Trent Parke of strange light on a passing bus that he

returned for more than a dozen times over the course of a month until he caught it exactly as he wanted. Of the second approach, American mountain photographer Galen Rowell wrote, "I search for perfect light, then hunt for something earthbound to match it with."

These are the ideals for light-driven photography, but of course circumstances and the time you can spend mean that you will often need to shoot in less-than-perfect light. Even so, by understanding how light works on different scenes—how it reflects, refracts, and the layout of light and shade— you can still usually make an improvement. It's also no bad thing to take the attitude that all light can be very good for something.

Below: An unusual combination of lighting with pale-colored cliffs on the camera side of the canyon reflect sunlight up and back to the rocks.

LIGHT'S GOLD STANDARD

Much loved (perhaps too much), the light at the Golden Hour always delivers satisfaction. It's a crowd pleaser, but being so universally popular, it's a mixed blessing. It's now so common and so widely practiced that it risks becoming too obvious.

Nevertheless, it has a good pedigree and appeals to viewers as attractive for sound reasons. It's all to do with the sun being low—approximately 20° or lower—and so for much of the world, depending on the season, it's roughly the hour after sunrise and the hour before sunset. The color (which varies depending on how clear the atmosphere is) comes from the scattering effect that particles in the air have on light. The sunlight at these times of day is passing through a greater thickness of atmosphere, and particles scatter the shorter wavelengths of light—the bluer ones—first. What remains is therefore less blue and more orange, and the closer the sun is to the horizon, the more the color approached red.

It works viscerally because the audience would quite like to be there physically, but more than that, the golden color is inviting, and the low angle has two conventionally attractive effects on the image. One is that it rakes the surface of a landscape, throwing it into relief with a combination of light and shade, and this gives things more definition. The other valuable effect is that it gives you a three-point choice of shooting direction. You can shoot with the sun more or less behind you for punch and richness; with the sun to one side for strong modeling of most subjects; or into the sun for atmosphere, contrast, and silhouettes. In other words, it increases the variety of imagery possible in a short amount of time, which is always a good thing. This combined with unexpected details catching shafts of light as the sun goes behind buildings, trees, and the like, generally keeps photographers very busy. Late afternoons are a little more predictable than early mornings, simply because you have the earlier part of the afternoon to see the way the sun is moving.

Opposite: Shooting into late afternoon sunlight in a Buddha-carving street in Mandalay, Myanmar.

Top: A very different effect with the sun behind the camera at London's Tower Bridge.

Bottom: A third lighting angle for Golden Hour is cross-lighting, here in Shangri-La, western China.

MAGIC HOUR

Between Golden Hour and night is the nuanced and delicate Magic Hour. After the sun sets in a clear sky, all the normal dynamics of light change. Gone are shadows and contrast, and the balance between the colors of the light on different sides of the sky suddenly becomes almost even.

The result is a short period of time when the light is delicate and shifting. The same happens in reverse before sunrise, so you get two chances a day in good weather. The term comes from the movie industry, and the most famous film shot entirely during Magic Hour (it's incredibly expensive to do this) was from Terrence Malick's Days of Heaven in 1978, shot by director of photography Nestor Almendros.

Like Golden Hour, the actual time depends on latitude and season, and of course it also requires a clear sky. Color is Magic Hour's strong suit, as there's a subtle but distinct opposition between the warm hues in the direction of the sun and the

bluish ones on the other side of the sky. At this time, they're more matched in brightness so that eventually you have two opposed soft-light sources bathing a scene or subject from either side. Look for reflections in particular; bodies of water do particularly well at Magic Hour.

A small slice of Magic Hour, immediately before nightfall, is the short-lived (often no more than 10 minutes) blue evening light when the sky becomes a rich, deep blue, just bright enough to work as a backdrop for silhouetting buildings and trees. Architectural and hotel photographers love it for two reasons. One is that there's a natural complementary-color balance

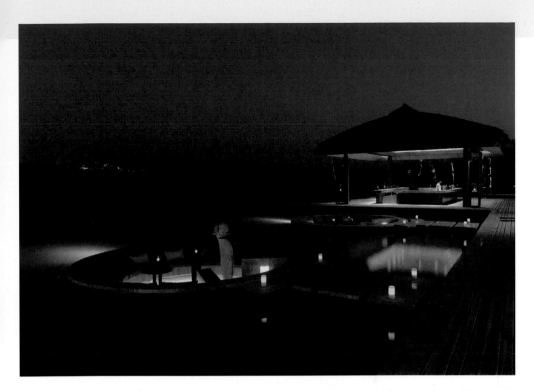

Above: The 10-minute window of opportunity at dusk, at which the brightness of the blue sky and the orange lighting is balanced.

Below: Looking east before sunrise at the temple-strewn plain of Pagan, Myanmar contrasts pink sky with blue shadow.

between the blue of the sky and the orange of the artificial lighting that is automatically pleasing. The other is that the semi-darkness acts like theatrical makeup to conceal blemishes and any ugliness in buildings. The problem is that it lasts for only a few minutes. Even when you are prepared for it, having chosen your viewpoint and tidied the scene up in front of you, your eyes' clever adaptation to the slowly failing light can give you a different perception from what the camera sees. A good rule of thumb is to start paying attention about half an hour after sunset in mid-latitudes, and then begin to use Live View and take some test shots to look at the balance of colors. Use Auto to cope with the changing light levels, or try Manual with plenty of wide bracketing. For the richest blue, shoot away from or at right angles to the last remains of the sunset.

LIGHT & WEATHER

Golden Hour and Magic Hour are, of course, not the only desirable light for photography, even though they do attract disproportionate attention.

Both are premised on clear skies, but most of photography's light comes modified by weather—clouds, mist, fog, dust, haze, etc.—and the permutations are endless. Here are some of the better-known varieties.

Below: Late afternoon sunlight behind the camera lights up storm clouds to the east, to make a delicate two-toned light over a London street.

Soft Sunlight
- haze softens shadow edges and reduces clarity, but the day still remains sunny
- flattering light for many subjects, because light-to-shade contrast is less; modeling is definite without being harsh

Gray Light
- shadowless light from complete overcast can be useful if you want restraint
- good for recording fine details of a large structure, like an industrial plant or garden
- contrast between ground and sky can be problematic; try some shots without sky

Soft Gray Light
- overcast light with the addition of haze
- brings depth and atmosphere to long shots
- can be delicate and moody, with distance disappearing into sky
- allows a choice of exposure, from brighter to darker

Dark Gray Light
- heavily overcast, usually with some cloud texture and some lightening of the sky toward the horizon
- stormy weather; get the best out of it by including sky and keeping exposure down, darker than average

Wet Gray Light
- falling rain or soft drizzle
- atmosphere similar to the haze in soft gray light (above) but with the addition of glistening surfaces

Rain Light
- a special wet-weather light variety when rain is lit up by shafts of sunlight
- reveals rainbows if you face away from the sun
- shooting into the sun can light up sheets of rain for a special sparkle

White Light
- an enveloping thin mist, over or near water or snow
- gives a shadowless bright light that surrounds everything

Storm Light
- the brief and unpredictable moment when sunlight breaks through thick storm clouds
- great for landscape photography
- usually works best when you contrast the spot lit area with dark surroundings

131

Dusty Light
- dust particles are larger than the water droplets responsible for haze and give a thicker atmosphere
- often occurs after a sandstorm
- also occurs in heavy pollution

Misty Light
- mist vs. fog is a matter of degrees of visibility
- mist allows you to see further than a kilometer
- subtle separation of the landscape is where misty light is most valuable

Foggy Light
- on a foggy day or in a cloud on a mountain
- typically shifts in thickness, frustrating if waiting for it to clear enough to reveal something
- unpredictable, but highly atmospheric

INTERIOR LIGHT

The lighting in interior spaces works in a totally different way from natural light outdoors. There's much more variety, partly because interiors themselves cover such a wide range (from airy public spaces to small domestic ones) and partly because, unlike the outdoors, there's a shooting balance between daylight and artificial light fittings.

Some of this you have no control over (i.e., the sun may be streaming through one window when you begin, but then disappear behind clouds), but much of it you can plan for. Waiting for the end of the day will shift the balance from daylight to artificial, but there are options such as drawing blinds or covering windows with a translucent material like scrim or even a white sheet of cloth. On top of this, you can always bring in photographic lighting as a supplement or fill. Domestic interiors in particular are manageable in size when it comes to added lighting.

One persistent feature of interior lighting is the high dynamic range, especially if you shoot toward a light source, such as a window during daylight hours. The traditional answer is fill lighting from photographic lights, but a highly controllable digital way of doing things is to shoot a range of exposures to create an HDR file, and then process that to open up shadows and recover highlights (see pages 94–97).

With all this choice of light sources and processing, there are endless styles and it all ultimately comes down to taste. Lighting styles have been explored over the centuries by painters, and one of the most valuable resources you have is seeing how classical painters handled their interiors. A particular favorite of mine is the cool, calm, and atmospheric lighting developed by Dutch

painters of the 17th century, in which soft, directional light comes from one side and slightly behind so that about a third or a half of the subject is in shadow. The master was Johannes Vermeer, creator of famous paintings such as The Kitchen Maid and Girl with a Pearl Earring. The setup, easy to follow photographically, is a large window just out of view but with no direct sunlight streaming through. Allow shadow areas to stay dark without attempting to open them up much, and have some distance behind the subject without much background detail. The effect typically gives good modeling to subjects, which also stand forward from the background.

Below: Direct sunlight through windows and doorways can create an unpredictable, often dramatic set of lighting effects. The reflection on the face comes from sunlight striking the floor.

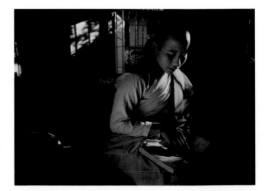

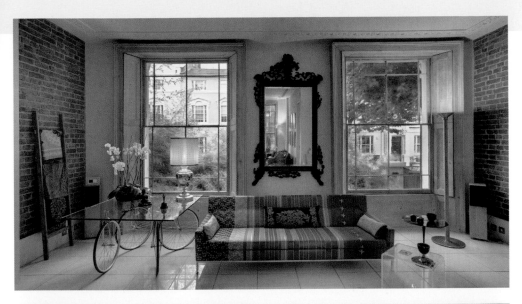

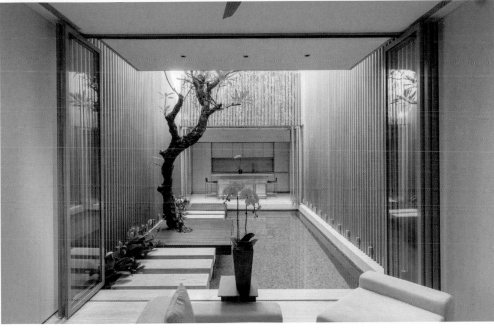

Top: Shooting toward large windows with only natural light is good for atmosphere but usually calls for HDR techniques.

Bottom: A light well over the indoor pool in this house gives good contrast without the extremes of an open window.

CONSTRUCTED LIGHT

The reason for the huge choice of lighting equipment that we saw on pages 62–73 is to be able to construct from scratch any kind of light effect that can be imagined, from simple to subtle and complex.

One of the biggest creative problems in studio lighting is that, in aiming for efficiency, it's easy to lose sight of being interesting. Commercial photography in particular usually has a need to present objects in a "correct" way according to the client's needs. In the real world of natural lighting, however, it's the fleeting, strange, and rare light moments that tend to catch the imagination and make a striking shot. Being able to create such idiosyncratic effects in a studio calls for a high level of knowledge and a constant attention to staying imaginative. In other words, to be able to create lighting successfully, you must first know how natural light works.

As we've just seen in the last several pages, natural light can be immensely rich. There is almost always more than one light source in a scene, even if there is a single origin. This is not a paradox. The sole origin of daylight is the sun, yet its light is reflected by almost every surface it strikes, refracted by transparent objects,

shaded by others. For example, sunlight bouncing off a white wall is a second source of light added to the direct sunlight. The same applies to studio lighting. First, learn to analyze the mechanics of light falling on any given scene: how it falls and what influences it and alters it. Simply observing analytically is the best training you can have in order to be able to construct lighting, so do it especially for any uncommon lighting effect that you like and want to be able to mimic.

In fact, attempting to reproduce natural-light effects with lighting equipment is a very good practical exercise, and not always easy by any means. The sun is so distant that it works as a point source, while most lamps have some dimension. The list here shows the eight variables for any studio light. Only the first, brightness, has nothing to do with light quality, but of course it affects cameras settings like aperture, shutter speed, and ISO.

Right: A rabbit skull lit diffused from both above and below so as to both reveal all the details and to make it 'float' in a white limbo.

The Eight Variables In Studio Lighting

We can define a light source by the following eight variables. Variables 3, 4, and 5 determine the critical relationship between light and subject on a scale that ranges from spotlight to enveloping light. This in turn determines the shadow fall. The key to successful studio lighting is to be able to control all eight variables. Possibly the most physically difficult of these are shape and position.

1. Brightness
2. Color
3. Size
4. Distance from subject
5. Shape
6. Position relative to subject
7. Position relative to camera
8. Direction

Above: The lighting set-up involved a translucent curved light-table, top medium light bank and smaller upward-aimed light bank.

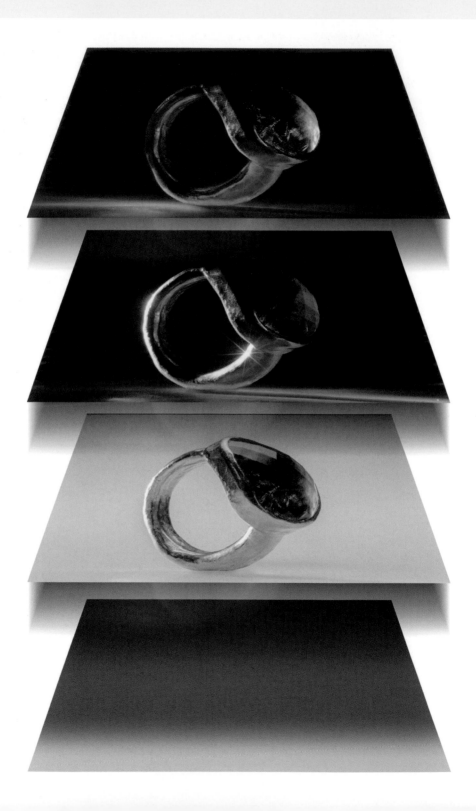

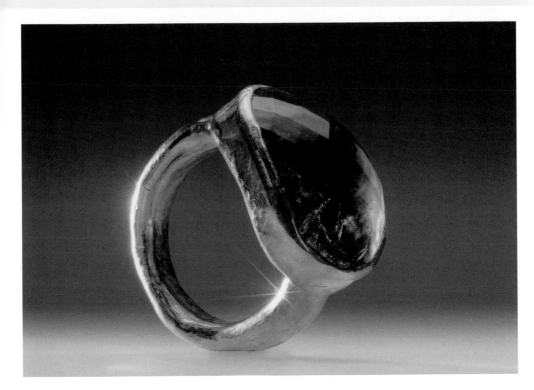

Left & above: An amethyst and gold ring,
photographed in three separate stages as in the
set-up illustration, and the three shots composited as
layers in Photoshop.

Left: The lighting set-up for this
jewelry shot includes two focusing spot
Dedolites to create highlights left and
right, in addition to the top medium
light bank.

HIGH KEY, LOW KEY

Two extremes of lighting style are the light and bright high key and its darker, more moody cousin, low key. Both terms started in the movies and were fairly technical, but they evolved to become widely recognized styles that can come from natural light as well as the constructed lighting in a studio.

The "key" part of the terms refers to—or used to, anyway—the single main light used traditionally on movie and television sets. Standard and not particularly imaginative, this three-point lighting featured one main light (the key), a fill light for the shadows, and a back light for the hair or to highlight contours and help make the subject stand out from the background. High key meant balancing these so that the lighting ratio (between key and fill) was low, with no deep shadows.

Nowadays, a large bank or umbrella is more common in studios, as it softens and reduces shadows more effectively, but the treatment calls for overall brightness. This doesn't mean overexposure, however, and for high key to work well, there need to be smaller darker elements, too. In other words, while the contrast over most of the frame is very low, when you include the small, darker parts, there's actually a full range of contrast. As in the example below, the main subject can even be the smaller, darker part.

Low key, which in cinema was the basic lighting technique of "film noir," is the opposite in that it's dark overall, but it is also created by very different means. Low key relies on a very high contrast ratio, but at the same time the main subject is hardly

Below: Specular lighting adds sparkle and contrast to this shot of a dessert, but relies mainly on the brightly lit glass dish for its high-key effect.

ever fully lit, unless it's exceptionally small in the frame. Rim or edge lighting is very typical of a low-key shot, whether constructed by using a kicker or similar small backlight, or in the natural world, as in the shot above. Against a dark background, it can bring a sense of mystery by being less than obvious, forcing the viewer to spend a little time working it out.

Above: A low-key "remains of the day" atmosphere comes from keeping the exposure down and catching the last weak sunlight through a window the also provides weak overall lighting.

COLOR

Just as you can push light toward being the most important element in a photograph, so too can you make color itself almost the entire subject. It sounds straightforward, but beware. Everyone likes a pretty shaft of light, but color provokes opinion.

We experience color differently from other visual effects; the brain processes it in a unique manner and it affects emotion. Our emotional response to color is complex—affected by culture, memory, and biology—but the net result of association and symbolism is that people actually like and dislike colors and the ways in which they're combined. Everyone has opinions about color that hardly ever have to do with the other ingredients of an image.

One thing you can be sure of is that if you use color firmly and deliberately in your photography, you'll acquire both fans and critics. When the American New Colorists came along in the 1970s, they scorned the rich colors of Ernst Haas, Pete Turner, and Jay Maisel (critic Max Kozloff dismissed Haas as "the Paganini of Kodachrome"). As ever, style and taste play a large part in this. Just remember that one photographer's subtle color is another's drab. The next few pages show how color can convey a sense of place, atmosphere, and mood.

Above: A pink cotton cloth covering this Chinese birdcage suffuses it with a single color.

Above: A glacial meltwater lake with submerged trees, which add some green to otherwise turquoise scene. The framing carefully excludes anything other than the water to maintain the single-color theme.

Light & Color

These two are inextricably linked, not only because light has a color of its own, but also because the direction and clarity of it affects saturation, highlights, and shadows. These in turn affect the style of color, as follows:

- Rich colors are enhanced by two kinds of light: clear axial light (such as in clear weather with a low sun behind the camera) and soft gray diffuse light.
- Muted colors stay restrained under soft and shadowless light that keeps the contrast down.
- To help avoid shadows weakening colors, compose to keep them small in the frame and expose down to keep them as dark as possible.
- Highlights are often more of a problem than shadows for weakening color. To avoid this, either keep them small (specular highlights from a single source like a clear sun) or shoot in diffuse light that spreads the area of the light.
- Dusk in clear weather often turns skies into pastel colors, and these reflect subtly off surfaces.

Color Terroir

The idea of a palette of colors is a set that in some way works together and conveys some mood and atmosphere. In photography, you can take this a step further and search out the colors that convey a sense of location. One of the ideas promoted strongly in the wine industry is that of terroir, the French term that means the combination of aromas and flavors that identify a wine as coming from one specific place and no other. It's not too fanciful to translate this into other ways of identifying the specialness of a particular place, especially its colors.

Some are more obvious than others, but it makes for an interesting way of exploring with the camera to try and identify what the underlying combination of colors is for wherever you've chosen to walk around and shoot. The example above happens to be more distinct than most: Sparsely populated Iceland is known for its dramatic but bleak wild landscapes, and maybe in reaction to this, Icelanders often use splashes of striking color, particularly for roofs. Color accents (see page 208) like this are typical of the country's landscapes. Try this in a location near you, or when you next travel:

whitewashed Greek islands, heather-covered Scottish glens, blue-green Norwegian fjords, or combination of ochre and adobe in New Mexico with yellow, red and turquoise. You can assemble a color palette that describes the landscape (or townscape), light, and culture, and with this in mind, you can look for a set of images, each with one color, or even scenes that combine several of them if you're diligent and lucky.

Top: Grays and cool neutrals are characteristic of Iceland's volcanic landscapes, but equally typical are the splashes of color on Icelandic roofs, making this combination resonant of the much of the island.

Bottom: The color theme deliberately captures here is of old wood panelling, which blends with the adjacent yellow-browns of ambient-brewed tea for a still life.

Concord & Discord

Colors need other colors to mean anything, at least in photography. Even if there's a single, dominating color, regardless of how much you like it, there almost always has to be a different color to set it off and counterbalance it visually. Inevitably this means combining different hues in the same frame, and while you'll have a gut reaction based on what attracts you and the point of the photograph, it helps to know the basics of how the eye and brain normally relate colors. Just about everyone has an opinion about which colors go well together with others and which clash, and there are countless contradictory opinions. The result doesn't have to be attractive; color clashes can be interesting even if the result looks less than tasteful.

The color combinations that most people find harmonious are called complementary and they have a real basis in human vision; they're not just someone's opinion. Basically, colors opposite each other on the color wheel are generally perceived as fitting each other. So, for example, red against green, blue against orange, and violet against yellow are usually satisfying, although unremarkable. J.W. von Goethe put an extra gloss on this by showing how the best matches take into account the different brightness of colors. Pure red and pure green have the same brightness, so a "perfect" proportion is 1:1. Blue and orange match at 2:1 and violet and yellow at 3:1. However, as with all tasteful formulae (like the Golden Section), just being visually polite isn't going to make a photograph better. For the most part, finding and combining colors involves careful framing by moving closer or further, and by choosing a focal length that opens or closes the area.

Above: The strong viridian green, blue, and orange could be considered to clash in conventional terms, but all color combinations are ultimately a matter of taste.

Opposite: Primary colors in a single frame is the theme of this image in South America, and gives it a basic harmony.

Rich or Restrained

Rich colors are like strong flavors in food. They punch, give a kind of instant gratification, and most people like them… at least for a while. Subtle they are not. In the more scientific Hue/Saturation and Brightness way of looking at color, rich means high saturation and slightly darker than average. Kodachrome achieved its special reputation for such rich colors, provided that it was a tad underexposed—a standard professional technique at the time. Relying on over-processing to get richness is really poor technique; instead, it depends on first finding inherently saturated colors in the scene, and these are easier to find in some places than others. Lighting needs to be either strong and more or less from behind the camera or else diffuse lighting (as in shade), and in either case no overexposure. Processing should

complement, and the sliders are all there for your consideration. Raising contrast and lowering the black point usually helps the cause, but raising saturation significantly in processing is something you shouldn't ever admit to your closest friend. It's too easy and too artificial.

The opposite treatment from rich is the subtle exploration of de-saturated hues, considered by some more sophisticated and less crowd-pleasing (see "Quiet Color and Light" on page 200 for more on how important this is in the art world). As with rich colors, it's ultimately about taste but practically is a combination of the actual found colors and the way you handle them. Much of the natural world is quite restrained in color to begin with, meaning low in saturation. A side effect of this is less contrast than with rich colors, and that

makes it easier to combine different hues harmoniously. For instance, earthy colors are really just de-saturated reds and yellows. When muted colors are bright—which can be your choice through exposure—they're usually called "pastel." In the food analogy I started with, a restrained palette is subtle flavor, best enjoyed calmly and slowly.

Opposite: Rich saturated color, from backlighting through sunglasses, beer, and a green bottle, creates the basic appeal of this found still life.

Below: The low color saturation, almost monochrome, of a wintry, cloudy day creates a melancholic atmosphere.

BLACK-AND-WHITE REVIVAL

Just as you can push light toward being the most important element in a photograph, so too can you make color itself almost the entire subject. It sounds straightforward, but beware. Everyone likes a pretty shaft of light, but color provokes opinion.

Apart from a few obscure and difficult processes like Autochrome, photography in the beginning simply meant black and white. Generally, this persisted right up to the 1960s, aided and abetted by the standard printing methods for magazines and books. Color was the exception, but as soon as it became available easily to everyone, it almost swept black and white away. Color was like the real world, color was exciting and enjoyable, and from Kodachrome to modern digital sensors, the colorfulness of photographs became one of their major virtues. A hard core of black-and-white photographers remained, mainly in the art world and in the purer realms of reportage and street photography. Now, however, there's a black-and-white revival, maybe as a reaction to possibly too much color washing around, maybe even a harkening back to tradition, but also because the three-channel way in which digital cameras record gives photographers unprecedented control over how their images can translate into monochrome.

The fundamental appeal of black-and-whites is that, by definition, they're a distance apart from reality. We see and experience the world naturally in color, and so most photography naturally follows suit. However, this brings with it the expectation that a color image should somehow be accurate and represent what the scene actually looked like. Black-and-white photography isn't burdened by this—it's automatically an interpretation rather than a representation, one step removed from reality. If you want creative expression, realism doesn't serve you very well, and that's a plus for black and white. Color is universally available, and even more to the point can be processed for richness, vibrancy, and super-saturation (which it is, too often). This, maybe perversely, has given black-and-white a status almost of refinement. Also, the digital conversion process that we'll see on the following pages gives much greater creative control. Henri Cartier-Bresson said, "Black-and-white photography abstracts things and I like that."

Above & right: Conceived at the time of shooting as a black-and-white photograph, the picture-postcard character of solid blue sky, red roof, and green leaves are dramatically converted during processing into a graphic image. Lowering blue and cyan blackens the sky and shade, while raising red makes the roof of this Chinese gate tower contrast with the sky. The overall effect is of overlapping triangles, and black-and-white conversion is principally responsible.

When to Convert

Black-and-white conversion is one of digital's major contributions to photography. Since almost all sensors record three channels of color, all that information can be used to choose exactly what tone of gray any color should become. This is not only a powerful tool, but you can choose to apply it at any time, well after shooting. That brings a truly new kind of choice. Back in the day, you had to commit to color or black and white when you loaded the film, and many photographers committed in principle anyway. This meant that if you were shooting in black and white, you were already composing images without their natural color—a unique creative process from composing color photographs. Now there's total freedom of choice, and you can revisit images to turn them into very different images.

The advantages are obvious, but this freedom carries with it something less useful: the encouragement to think less and play more. Using black-and-white imaging effectively demands an understanding of what it does better than color photography. The core visual values are that it emphasizes line, shape, form, and texture, and that it's open to a wide interpretation of the tonal scale, from dense blacks and hard whites to subtle, long ranges of gray. Some scenes and subjects have more potential for these than others, and some simply have problems in color that black and white can solve.

Problem-solving situations are mainly to do with color or light, and often one of these affects the other. For instance, you may not like the colors and shadows in the middle of a sunny day. Black and white may be the answer, because if not exactly immune to the time of day, monochrome is much less bound to it than color photography is. Or there may be some strong patch of color in a detail of the scene that distracts attention from your main subject. With a series of images, black and white can tie them together when in color they may stand apart because of different palettes; you could think of this as an extreme form of color grading.

Above (both): Two desert landscapes taken in the same area of the Red Sea Hills in Sudan, treated as dramatically as possible with black-and-white conversion. The orange and yellow rocks and sand set against the blue sky make an easily achieved tonal contrast.

Opposite: This incised meander in the upper Yangtse River, Yunnan suffered as an image from a dull range of brownish hues. Exaggerating the color saturation and then converting to black and white with high contrast made it possible to bring texture and definition.

Reasons to Convert

1. Problem Solving
• Don't like the colors
• Don't like the light
• Continuity

2. Black-and-white Values
• Line and shape
• Form and modeling
• Texture
• Abstraction
• High key, low key

Black-and-white Conversion How-To

For full control, do this using software on the computer, not leaving it to the camera. There's a good choice of conversion software, some of it specialized, and all the programs rely mainly on mixing color channels to control what hues become which gray tones. The main differences are in how the controls are presented. The procedure here applies to any software but is shown for Photoshop (Image > Adjustments > Black & White). There are alternatives for each of these steps in any conversion software.

1. Open the Black & White dialog window. The Preset field will show Default.

2. Check and uncheck Preview a few times to remind yourself of the colors and to see what shade of gray each is being converted into by this Default set of sliders.

3. A very good introduction is to go the Preset dropdown menu and go through each of the other 12 presets to see how the image changes between them. Some of these are extreme, showing a wide range of possibilities. Try and make judgments about what parts of different conversions you like. Make a mental note of these, and also see how the sliders are set for each Preset. You can probably learn more about black-and-white conversion from studying this set of presets on your own image than by any other means.

4. Remind yourself of your original assessment of the image and what basic conversion effect you are looking for (such as overall bright vegetation, darker sky or lighter sky, brighter or darker skin tones, etc.).

5. Be aware that most colors in an image contain more than one slider component, and this can be useful in making a variable conversion of a picture element. For example, a clear blue sky visible down to a distant horizon will contain both Blues and Cyans, but variably. The Cyans will predominate closer to the horizon. This makes it possible to have either a strong contrast within the sky (brighter Cyans and darker Blues), or a more evenly toned sky overall (darker Cyans and brighter Blues). Green vegetation usually contains Greens and Yellows and can be similarly converted variably.

6. If there are separate picture elements with similar colors (or at least affected by the same color slider) and you want to change just one of them, consider the more complex step of making a duplicate layer and two different conversions, then partially erasing the upper layer to combine them. This is quite a bit more work, but several layers make it possible to convert every color and every part of an image independently if you so choose.

Opposite: In this photograph of a Burmese marble sculptor in Mandalay (see also page 126), the aim was to point up a coincidence between the two faces, one with a shadow, the other with a mask. The technique of over-saturated initial processing allows more contrast in the later black-and-white conversion—notably between the purple mask and the skin tone.

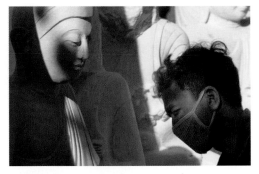

The color original

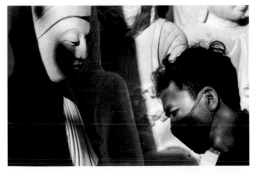

Black-and-white conversion from the color original.

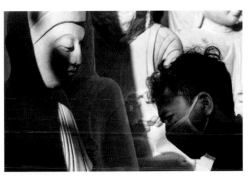

Over-saturated version for more striking conversion.

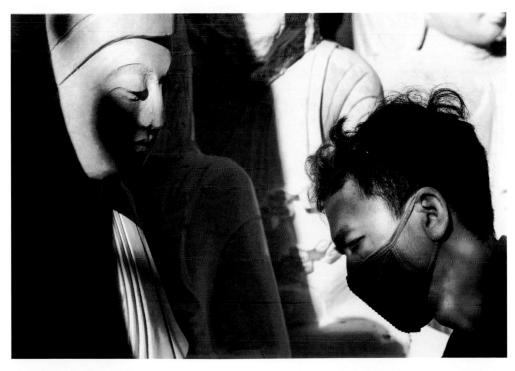

Rich or Long Tonal Scale

An inheritance from wet darkroom printing is the amount of processing interpretation that black and white allows—much more than color. The basic reason, as mentioned previously, is the expectation that color imagery is reasonably true to life, while black-and-white imagery has no such baggage. Oversaturated and hyper-detailed color processing (see "HDR for Adults" on pages 94–97), however widespread, helps prove the point. It looks strikingly unrealistic, while even the extremes of hard black-to-white monochrome stay acceptable to most viewers. Two persistent aesthetics that have remained in black and white photography for more than a century are, on the one hand, strong contrast with deep blacks, and on the other, the subtle definition of mid-gray tones. In the first, dense shadows are set against pure whites, with an almost luxurious feeling in the richness of blacks and near-blacks, like a heavy inking in other kinds of printing or painting. Two variations on this are high key and low key (see pages 138–139), each with a massive imbalance between the dark and bright areas.

In the second, a long range of grays comes from the legacy of platinum and palladium prints, which started at the end of the 19th century. As an alternative process, they are enjoying a revival, and while this isn't really relevant to us here, the side effect is a different black-and-white aesthetic, one in which the middle grays are expanded and separated. The result may not be as exciting as the punchy effect of strong black to strong white, but it has the appeal of subtlety and restraint. There's less emphasis on graphics and blocky shapes and more on nuance and the information in the image.

It's a common misconception that platinum and palladium prints have a very long range, while in fact it's considerably less than a normal black-and-white image because the darkest and lightest tones are nowhere near true black and white. Instead, the notable feature is separation of the mid-tones. As with any low-dynamic-range style of imagery, you can choose to work in the middle, darker, or brighter tones.

Below: A high-altitude mountain pass converted to black and white for maximum contrast and an overall rich, dense effect, from pure black to white.

Right: An Amazonian tree just emerging from morning mist called for the opposite treatment—a narrow mid-range of grays from the middle of the tonal scale.

Photography, like any creative act, always has to balance performance with subject—form versus content, in other words. At one end of the scale are almost pure abstractions of composition or color or light and shade, images that rely entirely on their sensory appeal. At the other end are photographs that are completely focused on capturing the subject in front of the camera, artlessly. Many news photographs are like this. Most images fall somewhere in between these two extremes; they're about a class of subject and so follow certain conventions about how to treat them, but at the same time they need image-making skill put into them in order to be effective.

The most traditional way of looking at photography is by the type of subject, but things are no longer quite as simple as they used to be. In the old order, photographers tended to describe themselves in this way—as a landscape photographer, portrait photographer, sports photographer, street photographer, and so on. Many still do, particularly when the subject calls for specialized techniques, like wildlife. As I've mentioned, though, the documentary role of the camera is no longer as strong as it once was. Subjects are no less important than they used to be, but simply getting an efficient shot no longer carries much weight. It used to be possible to say that this or that kind of subject demanded such and such treatment, but now there's much more experimentation as photographers test the boundaries of traditional subject matter. The standard subject categories of photography are being refreshed.

3

SUBJECTS

PEOPLE AS THEY ARE

There's arguably no better match between an art form and its subject than between photography and people. People are the most mercurial, most emotionally compelling and most vital subject for both imagery and writing. Nothing else approaches them in complexity.

In imagery of any kind, they reveal themselves in the way they move, hold themselves, and express themselves, and this can change in the flicker of an instant. This is what makes photography the natural medium for people as a subject: its unique capacity to capture finely sliced moments. No other medium can do this, crystallize the character of a person in a single capture, and when it works, it's far more powerful than a time sequence caught in video or film. More powerful because the photographer has to choose that exact moment and present it.

There are two fundamentally different ways of photographing people: with and without their knowledge and cooperation. This is not simply a matter of asking

Below: A pensive expression crosses the face of a salesgirl in a Moscow department store in between serving customers.

permission, which is in a way trivial. Photographing people without their knowledge (candid shooting) means being an objective witness to events and interactions; there is a kind of purity to it. It's almost the universal ideal of street photography, to the point that when someone looks at the camera, most street photographers feel they've lost it and move on. Nevertheless, there's very much a place for the camera-aware shot, and it doesn't have to be comfortable to be effective.

American photographer Bruce Gilden has made a distinctive style out of photographing strangers from close and very directly. It depends very much on the way you choose to interpret the look on the subject's face and its intensity. A plain I-just-saw-you look, or worse still a grin, has little merit, but a steadier gaze, particularly with some confidence and strength, can arguably make the image more powerful than if life had been going on without you being noticed.

Left: In complete contrast to the picture opposite, hyperactive excitement on the face of a young South American girl with her mother.

Left: Traditional street life in the town of Mahébourg in Mauritius includes an old-fashioned barber shop

EXPRESSION, GESTURE, POSTURE

People express themselves visually for the camera in three ways, each at a slightly different scale. From close up there's expression, which happens in the face. Then there's gesture, usually from hands and arms. Third, there's posture, meaning the whole body, whether standing, sitting, or moving.

It's unusual for all three to be strong at the same time, but when you're shooting it's important to aim for at least one that comes across distinctively.

Almost without exception, people in front of the camera become interesting and worth photographing when they move and express themselves in definite ways. Flat expressions, slumped postures and unexceptional movements just do not cut it in photography. Ordinariness is the default, so why would it be worth a picture? Your audience is automatically primed to be interested in looking at pictures of people, but only if they look interesting. One way is if they're physically unusual— from beautiful to grotesque—and this has been done on the fringes of mainstream photography. Another is if they're famous, but ultimately the interest value of people in photography for most of us who shoot comes down to the way they behave.

Below: In an outdoor Brussels cafe, one slightly flamboyant customer combines with expression and gesture in one moment.

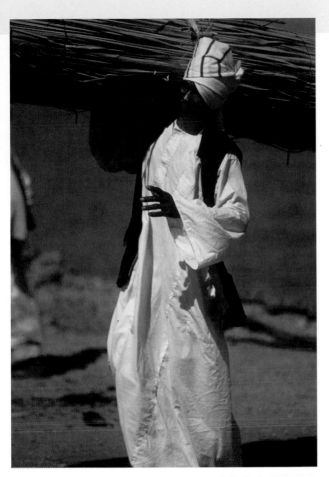

Left: Posture involves whole-body movement, here with an elegant flow as a Sudanese man carries his load along the street

The smallest scale of movement and moment in people photography—yet also often the most powerful—happens in the face. We're absorbed, even obsessed, by facial expression, to the point where most of us believe we can tell from it what other people are thinking and feeling. Expressions change; there's a constant passage across the face, like a "weatherscape," and some of them are going to be more resonant than others to a given viewer. Then there are the gestures that people make with fingers, hands, and arms (and very occasionally with their feet). The repertoire is huge, it varies socially and culturally, and at the distance scale of most street and reportage photography, is probably the main event when you're shooting and looking for an expressive moment.

Posture, or stance (there's no really good word that encompasses all the ways in which people position, hold, or contort their bodies), is in the largest scale of the three. At the distance from which you're likely to capture a whole-body moment, the face with its expression probably won't be very obvious. Posture is at its most distinctive in sports (or any really strong physical activity), but for that reason it's very much worth paying attention to in regular reportage or portrait shooting, as the nuances are often missed by casual shooters who aren't paying attention.

PEOPLE, POSED & ARRANGED

The essential difference between candid photography and portrait photography is simply awareness. With the former, as we've just discussed, the camera doesn't interfere with life; the photographer is simply a quiet observer. Here with portraiture, however, there's a kind of contract between photographer and subject.

The two collaborate, even if it's just for an instant in the street, and much more in a studio. The subject usually wants to look good; the photographer may or may not agree with this. In either case, there's a connection of personalities, and the focus of attention is nearly always the face, which is where expression is at its strongest.

The human face is a landscape crossed with shifting moods and feelings—or at least, the appearance of them. One endless debate among photographers is how much the surface of the face can actually reveal the complexity of the personality behind it. This is the "eyes are the windows of the soul" argument, and there are fiercely opposed views, even from great portraitists. The Canadian Yousuf Karsh wrote, "I try to photograph people's spirits and thoughts", while Arnold Newman believed, "We can only show, as best we can, what the outer man reveals. The inner man is seldom revealed to anyone, sometimes not even the man himself." Richard Avedon, probably the greatest portrait photographer of all time, had an even stronger view, saying, "There is no truth in photography. There is no truth about anyone's person." Even if Avedon is right, we all recognize, for example, the downward gaze toward nothing in particular, and we take it to mean that the mood is pensive and inward looking. True or not, it's very much a matter of timing, as are all expressions. Since the subject knows

you're shooting and agrees with it, you can, and should, take charge of the session to encourage or direct toward a moment that you feel expresses the character and mood.

Perhaps most important to remember is that the moment you choose to capture is your idea, not necessarily a truthful, representative, or even fair view of the subject him- or herself. Avedon, explaining why he used a general flood of light in his portraiture, said that it was so the subject could move freely, "so that I can get to them, to the expression they make, so that they are free to do or express something which is the way I feel." The point being in the last few words because, as he also wrote, "My portraits are more about me than they are about the people I photograph." Gesture and expression serve the photograph.

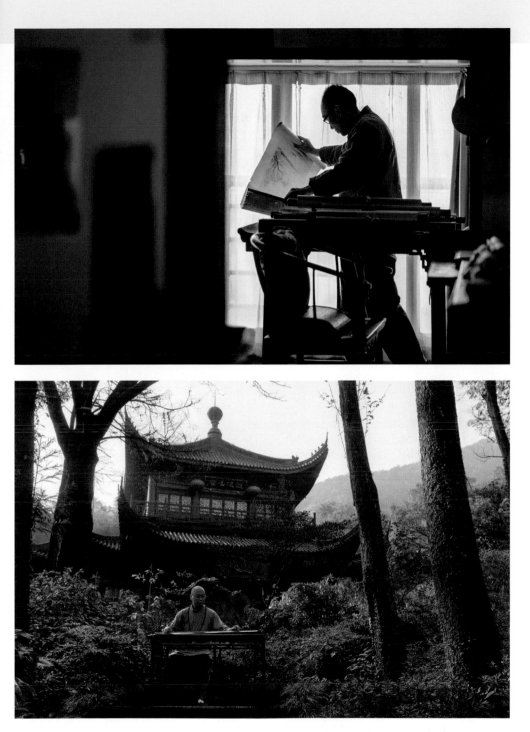

Top: A Chinese collector opens a scroll in a backlit setting that was chosen in advance.

Bottom: Planning and preparation also went into this temple scene, with one of the monks playing the traditional stringed instrument, the guqin.

SPORTS

Almost by definition, sports photography is about speed and moment and, in particular, what happens to the human body visually when it's in physical competition and under stress.

It's one of the genres most affected by equipment, simply because there's usually an emphasis in most sports on projecting the viewer close to the action (whereas in reality, spectators and action are almost always well separated), and on fast shutter speed. This puts a priority on long lenses and, in the professional world, a range of focal lengths in order to deal with fixed shooting positions at variable distances from the action. The faster these lenses, the better; those with wide maximum apertures allow higher shutter speeds, and the combination of long, sharp, and fast is always expensive. High shutter speeds also rely on very good sensor performance in low light, meaning that the ISO can be raised to 1000 or more without noticeable noise.

Shooting sports successfully depends ultimately on three things. The first is the right equipment, as just discussed. The second is knowing how each sport works, and the best sports photographers are those who know their subject intimately and can anticipate from second to second what may happen. The third, which is unfortunately being eroded for all but professionals, is the right camera position—access, which is more and more difficult to get. The basic reason access has become limited to the degree that it has is the monetization of sports and the competition for good positions among photographers and television crews. Even with access arranged,

more sports are televised, which means advertising appearing in shot.

Lower profile events and those that spread out beyond a stadium, like marathons and the Tour de France, make it easier for amateurs to shoot, but the practical key to success is nearly always a good camera angle, which is where a long lens comes in. It widens the radius from which you can close in on the action.

Below: Knowing in advance the route that this stretch of the Tour de France was taking through Gouda in The Netherlands made it possible to set up in advance and get a professional, unobstructed viewpoint of the peleton.

LANDSCAPE, SEASCAPE, SKYSCAPE, CITYSCAPE

Another subject that is undergoing change in contemporary photography is landscape. There was a time when celebrating beauty in spectacular landscapes went largely unquestioned as a worthwhile end in and of itself.

What gave value to the photographs of Ansel Adams, Edward Weston, and Galen Rowell, among others, was partly the spectacle and partly the skill and the effort that went into the shooting. Much of the effort was physical, as they actually tackled the terrain to reach a wonderful viewpoint; it was no coincidence that America, with its vast geography, was for decades the real home of landscape photography.

The search for exquisitely lit, breathtaking spectacles still goes on, and to destinations even more remote, but it is no longer the pinnacle of landscape shooting. First, there's by now a surfeit of similarly high-octane imagery—grand landforms, dramatic skies, and raking sunlight—and it's becoming more difficult to be surprising. Second, ever since Robert Adams wrote Beauty in Photography in the 1970s, serious landscape photographers have been forced to think about the less-than-pristine reality of our modern landscapes. Romantic idealism is beginning to look suspiciously like a dead end.

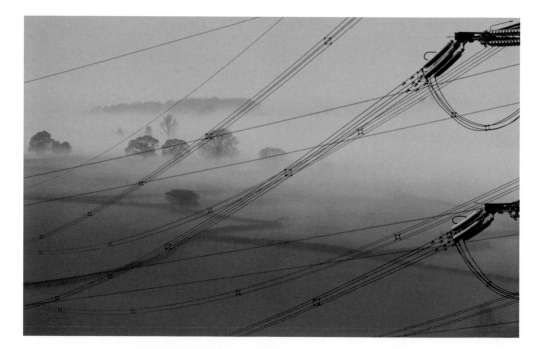

Above, top: These two rural landscapes depend on a purposeful viewpoint to elevate them from simple snapshots.

Opposite: What would otherwise be an obstruction can also be embraced, particularly in such a case as here, when there's very little fine detail to be found in the landscape beyond.

Screensaver landscapes are being challenged by a much wider range of interpretation, some of it critical and environmentally aware, some of it simply searching for new and surprising views of the planet. The biggest audience is still, and probably always will be, drawn to attractive imagery, but that doesn't have to coincide with conventional beauty. The standards of attractive lighting are not going to change any time soon, but there's a new appreciation of less-conventional weather effects. There's a new freedom from the obvious, not just in the subject material (i.e., over-photographed landmarks and scenes), but also in composition.

Landscape, more than most subjects, used to be plagued by rules of convention, such as where to put the horizon. As we'll see later, new landscape photography is now as open as any other subject to different styles. A very simple overview of the history of landscape shooting begins with straight and informative, then moves toward

dramatic with the increasing search for exotic places, and more recently includes the simplicity of quiet beauty.

In particular, minimalist style has been applied successfully to landscape photography. One of the most famous examples is "The Rhine II," by Andreas Gursky, which as of the time of writing is the worlds' most expensive photograph at $4.3 million. Looking for "an accurate image of a modern river," Gursky made an image reduced to the basics of three bands of gray

Above: While I can't very well recommend you put yourself in such situations, shots like this exhibit the higher standards of modern landscape imagery. Not only is the subject exciting, but the rendering is impressionistic and doesn't indulge in excessive dramatic contrast.

(path, river, and sky) interleaved with three bands of green (grass), saying, "I wasn't interested in an unusual, possibly picturesque view of the Rhine, but in the most contemporary possible view of it."

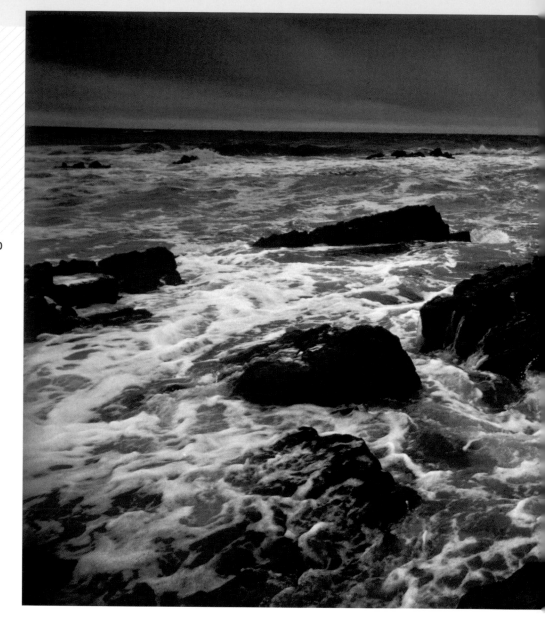

Hiroshi Sugimoto's series "Seascapes," all shot on large-format film with very long exposures, features a consistent symmetrical 50:50 division between water and air, which he sees as elemental, the reason for life on Earth. "Mystery of mysteries," he writes, "water and air are right before us in the sea. Every time I view the sea, I feel a calming sense of security, as if visiting my ancestral home."

Very far from the traditional scenic layout of foreground, middle ground, background, sky, landscapes are being redefined by photographers like Sugimoto. Seascapes and skyscapes have become an essential category in environmental photography, and which is which often depends on a slight shift in where the horizon lies. Either can be treated in a minimalist way, like Sugimoto, but they also lend themselves to

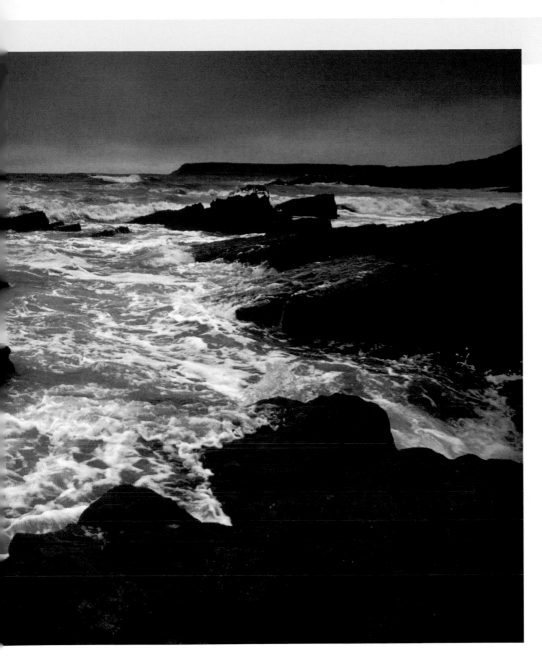

drama when the weather conditions are
right. Even without a horizon at all,
skyscapes can be full of incident, and one
relatively recent branch of landscape
shooting is storm photography. This is fast
moving, uncertain, and dangerous—
something new in what used to be a very
calm and measured area of photography.

Above: Here, drama was key, and the
weather and light invited a dramatic
rendering with a definitive color palette.

Landscape used to mean natural, but as more and more of it is being absorbed into the human world, that's no longer taken for granted. The built environment (to use a social-science expression) is gradually attracting more attention and occupying a larger part of landscape photography. The focus is not individual buildings or architectural style or even the way people live in cities, but the urban fabric—how it feels and looks. The urban landscape is what most of us inhabit, and what it lacks in romance and visceral appeal for viewers it certainly makes up for in variety and interest. It's likely that by now every spectacular landform on the planet has been photographed and displayed, but as the image here shows, the manmade environment is actually acquiring the strange and exotic year by year. Maybe there still is a future for that early ideal of landscape photography—to uncover and record places that most of us would never imagine.

Below: Street scene in Havana, distant from the usual cliché of colonial façades and fifties era American automobiles.

STRUCTURES

Contemporary architecture has never been so visually striking, and this is bound to have an effect on photography. There is no single architectural movement and all of it is strongly influenced by advances in construction technology.

Just as photographers like to push boundaries, so too do architects look for ways to be different and stretch their expressive possibilities. From apparently gravity-defying buildings like the Capital Gate Tower in Abu Dhabi and the Auditorio de Tenerife in Spain to the fractured asymmetry of Frank Gehry's designs or Zaha Hadid's sweeping fluid forms, what the leading edge of contemporary architecture has in common is the intention to astonish. Technology and wealth are at the heart of

this, and for the dramatic style of architectural photography, there has never been a better time. A distinct trend among architectural photographers is toward striking composition, lighting, and viewpoint to exploit the intentional drama these structures offer.

While this is the latest trend, there remains the huge backlog of historical buildings to be photographed. Traditional buildings tend to do well with traditional shooting techniques, i.e., keeping verticals

Above: Calke Abbey, an English country estate in classic Baroque style. Early morning raking sunlight makes the most of the façade.

Opposite: The Tofu House in Kyoto, a conceptually simple house that is austere yet 'floating', shot at Magic Hour.

vertical. This is one of the closest things photography has to a universally accepted way of seeing. It's very resistant to experimentation, because there's a strong disconnect between the way our brains process the actual view and the way a lens records it into an image frame. The optical solution is a shift lens (see page 49), but digitally, in post-production, it's relatively simple to distort the image to bring verticals into line. There are several software versions of a perspective tool.

What to Look for In Contemporary:

Architecture
- fluid curves
- rounded volumes
- large glass surfaces
- cantilevered structures
- new materials, including

Vegetation
- sustainable design
- imaginative lighting

Above: The British Pavilion, by designer Thomas Heatherwick, at the 2010 Shanghai Expo, is covered with 60,000 slender transparent fibre optic rods, each 24 feet (7.5 meters) long.

Above: A striking and strange contemporary interpretation of a Japanese Tea House built in Taiwan in the form of a tree house.

INTERIORS

Contemporary architecture has never been so visually striking, and this is bound to have an effect on photography. There is no single architectural movement and all of it is strongly influenced by advances in construction technology.

From a bedroom to a concert hall, interiors are among the most technically demanding of subjects. That said, once you've mastered the techniques of viewpoint and lighting, this is a very repeatable and predictable area. The checklist opposite shows what's involved from the technical side, but beware of letting this dominate the shoot; success ultimately depends on how you envision the shot and what information and mood you want to convey. This in turn depends on the kind of interior and its design style,

as well as on how the shot is going to be used (i.e., commercially or editorially). As just one example, if it's a historical interior, are there associations or meaning attached that needs to be expressed? Would it be valuable to communicate these in your images?

Below: A colonial 'Black and White' house in Singapore, given a deliberately airy and spacious wide-angle treatment to convey the open style (common before air conditioning).

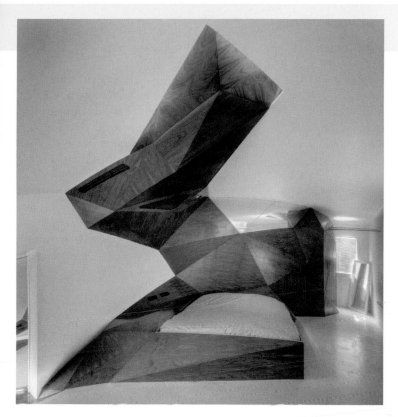

Left: In a conversion of a 1920s apartment in Shanghai, Singapore architects sciskewcollaborative embedded a multi-planed structure that runs through the several rooms to serve as furniture, cupboards and to carry utilities.

Viewpoint is always the first decision. The way we experience interiors for ourselves, by looking around, means that in real life we take in a very wide angle of view, but not all at once. This poses a problem for a still image, and usually the only way to come close to this effect is by using a wide-angle lens and shooting from a position that gives wide coverage. This position is often a corner, but then there's a risk of letting this became a standard formula, which can become boring. A wide-angle view also runs the risk of distortion for close objects and of empty, useless image space occupied by floor and ceiling, so these may influence where you place the tripod and camera. They may also be the reason for rearranging furniture and some objects if that's possible. In particular, recognizable shapes close to the camera and near a corner of the frame will distort. Additionally, it's worth considering how the room "reads" in terms of visual shape and what frame format will suit it best. Some interiors, for example, work well as panoramas, and a widescreen frame shape has the advantage (usually) of cutting down on the floor and ceiling.

Lighting is also extremely important, and if you have full access whenever you want, there's a considerable choice to be made.

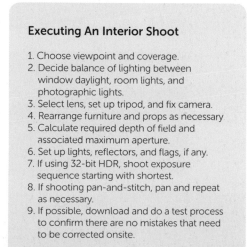

Executing An Interior Shoot

1. Choose viewpoint and coverage.
2. Decide balance of lighting between window daylight, room lights, and photographic lights.
3. Select lens, set up tripod, and fix camera.
4. Rearrange furniture and props as necessary
5. Calculate required depth of field and associated maximum aperture.
6. Set up lights, reflectors, and flags, if any.
7. If using 32-bit HDR, shoot exposure sequence starting with shortest.
8. If shooting pan-and-stitch, pan and repeat as necessary.
9. If possible, download and do a test process to confirm there are no mistakes that need to be corrected onsite.

Most interiors combine daylight from windows with their own artificial lighting, and the balance between these depends on time of day, weather conditions, and on your own choice of what lights, if any, to switch on and at what intensity (if any of them are on dimmers). If possible, take time to find out what the light choices are beforehand. (See also "Interior Light" on page 132.) This may be just a first step in the lighting, as you may need or want to supplement what's available with your own photographic-lighting equipment to lift certain areas or highlight objects. One typical supplementary technique is to light up an adjoining room glimpsed through an open door to help give a better sense of depth to the view. Another is to use a focusing spot to light up specific areas and enliven the scene. If you have just one or two lights but would like to light up more areas, shoot separate frames with the lights in different positions and then later, in post-production, combine these frames as layers. In this way, one carefully managed spot can light up an entire interior.

180

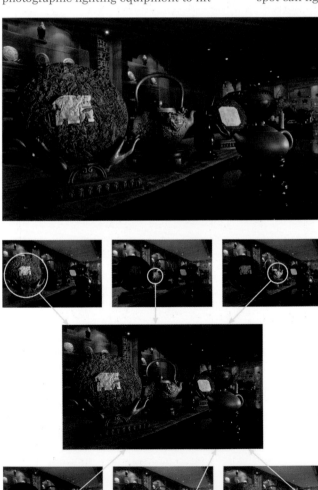

Left: An interior shot using one single focusing spot aimed at different areas in six exposures, assembled as layers in Photoshop in Lighten Mode.

Opposite: HDR technique and horizontal stitching combined for this interior shot entirely in natural light.

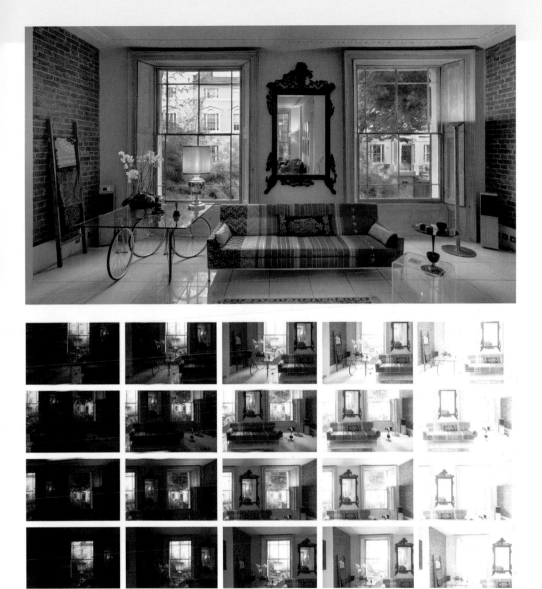

Unless you're absolutely confident about balancing the light all at the same time, you're strongly advised to shoot an HDR range to archive the full range of light from the brightest (usually daylight through a window, but excluding single-lamp light sources, which can be allowed to clip without causing any image problems) to the darkest. The general rule for this is to start with an exposure in which there is no highlight clipping (the shortest, darkest exposure), and then work up through an exposure sequence in 2-stop increments to the longest, brightest exposure in which the deepest shadows are exposed as mid-tones. Such an HDR file, if converted to 32-bit floating point, can be processed to solve any imaginable lighting issue. (See "HDR for Adults" on pages 94–97.) In particular, if you don't have photographic lights and feel they would have helped, you can skillfully use local processing with a radial filter on a 32-bit image to suggest the effect of a light being aimed at a particular area.

OBJECTS, NATURALLY

If there's an equivalent in objects to street photography, then surely it's the found-object still life, taking full advantage of natural lighting effects and settings that would be complicated to build up from scratch.

As we saw in "Constructed Light" (on page 134), it takes skill and experience to replicate all the complexities of natural light, which makes a good case for using the real thing. As for the setting, you might think that a small object doesn't need a large space around it, but as the shot here shows, a long throw behind allows you to make good use of selective focus for depth and contrast. In any case, between lighting and setting, the real world outside the studio is full of idiosyncrasy and the unexpected, which quite simply brings life to still life. Of course, rearranging and even repositioning is easy and certainly worth considering, but before interfering with a "found" still-life set, look carefully at how it is naturally. In a workshop or a home, things are often the way they are for a reason, and there's a risk that in "improving" an arrangement, you might

simply lose that naturalness. It's a style issue, and the main point of going down this route is to bring a casualness and spontaneity to still life that's largely absent from studio shooting.

Lighting also takes part in this natural style, and normally you'd be taking advantage of the existing conditions, as in the example here. Supplementary lighting or reflectors can add subtlety or lift certain areas, but equally, you could shoot a range of exposures for an HDR

Below left: A faded painting and rusted metal make a "found" street still-life from the unlikely source of an outdoor toilet in Chennai, India

Below right: Natural north light from a potter' studio and selective focus from a fast lens at full aperture create an atmospheric effect with little rearrangement.

image and then use 32-bit editing in a
Raw processor to make local adjustments
that can, if you're skillful, mimic added
localized lighting.

Top: A simple and unaltered market
stall display of salted eggs show that
clean still-life compositions can be
found almost anywhere, if you observe.

OBJECTS IN THE STUDIO

The normal, formal way of photographing objects is as still-life images created in the studio. At the scale of most still-life shoots, which generally don't need much more than a square meter of setting, studios can be makeshift, from a converted office space to any spare corner where the object happens to be kept, like in a museum.

The normal, formal way of photographing objects is as still-life images created in the studio. At the scale of most still-life shoots, which generally don't need much more than a square meter of setting, studios can be makeshift, from a converted office space to any spare corner where the object happens to be kept, like in a museum. In the professional world, to be sure, still-life studios are dedicated and fully equipped so that lights and backgrounds can be swung into place easily, but if you're prepared for the inconvenience of setting everything up each time, there doesn't need to be any compromise on quality of lighting—always a major ingredient in still-life imagery—when you shoot an object onsite. As we saw at the start of this book, studios are the most equipment-intensive spaces in all of photography, but much of that equipment can be handmade.

Purpose in still-life shooting goes all the way from pure product promotion to artistic experimentation, and in the life of advertising photographers where commercial demands are high enough to justify well-equipped studios, these two opposites often support each other. Making things look good and knowing how to enhance certain appearances and suppress others are commercial techniques, but learning them makes you a more skillful photographer and that's an exportable skill you can use. Less predictably, the creative process continues during selection, arrangement and lighting, with inspirations and surprises coming through the actual process.

As Robert Golden (one of the most successful and thoughtful advertising still-life photographers of his time) wrote, "There was always some testing going on[.] ... Often the tests, even the failures, refreshed the commercial work and constantly the commercial work refreshed the personal work." This is definitely one area of photography where I'd promote professional practice. You don't have to be a professional to work like one, and for once in photography, there really is all the time in the world to think, consider, and execute. There's absolutely no good reason not to.

Above: Stark lighting from a single focused spot (a Dedolite) makes shadows a physical part of this composition. The spot was aimed at each of the three tea-making items independently, and the shots composited in Photoshop.

CREATURES

As with landscape, old definitions are being refreshed when it comes to animals.

Wildlife, of course, is the high end of the photographic world of animals, but our closer animal relationships go way beyond mere "pets": working-animal relationships (which are sadly diminishing but therefore more urgently interesting to photograph), farm life, nomadic life, hunting life (both of and with animals), and yes, animals as pets, which might sound like the lower reaches of social photography but which can offer interesting sociological insights. There are also wild animals in various degrees of captivity, from zoos to nature reserves, some of which closely approach natural conditions.

Wildlife photography that is genuinely in the wild remains one of the most specialized areas of photography in all ways, and the standards and demands continue to increase. Its great popularity has made it highly competitive, not just between still photographers but between photography and television, where large audiences have allowed production companies like the BBC Natural History Unit to invest heavily in time and resources.

Simply efficient images of animals, which a few decades ago were sufficient to get attention, are no longer enough except for extremely rare species like the Snow Leopard. Behavior now dominates, and this calls for good behavioral knowledge, lengthy shooting assignments, great patience and, often, creative technical solutions.

Technically, the fast super-telephoto still dominates wildlife photography because it alone offers a close view, directly under the photographer's control, of animals that are either dangerous or easily spooked. Nevertheless, in the constant search for never-before-taken images, ingenious camouflaged hides are one fast-developing solution, including one-way glass. Making even faster inroads are remote cameras with flash, and the commercial success of GoPro has had quite an influence. The undisputed international showcase for wildlife photography is the annual Wildlife Photographer of the Year competition organized by the Natural History Museum in London.

Top: Rarity is one target of wildlife photography, here a Black-necked Crane from the Tibetan Plateau that winters in wetlands near Shangri-La.

Bottom: Another target is capturing wildlife exhibiting characteristic behaviors.

SMALL WORLDS

Macro photography (or more accurately, photomicrography) is about shooting at a scale close to life size. There's some disagreement about whether life size (meaning a reproduction ratio of 1:1 and a magnification of x1) refers to the image as shot or as reproduced in a print.

But it in any case opens up a world that's at a scale we normally don't pay much attention to in daily life. Macro shooting tends to go in one of two directions: informative, as in the natural world of insects and small plants, or abstract, which depends largely on taking details out of their normal, recognizable context.

The first is mainly a branch of wildlife photography and, in common with the endless experiment and effort that goes into that, contemporary macro shooting is highly inventive in the search for new imagery. Invertebrate behavior has become a major focus of macro photographers. The second direction, toward the abstract, exploits the unusualness of small scale. Divorced from their context, detailed shots can be independently graphic or colorful if you explore their purely visual possibilities. Part of the ethos of close-up photography is to direct attention onto something that we might ordinarily miss. These "hidden" details can surprise by their beauty and unexpectedness.

We saw the basics of macro lenses earlier on page 52, and their design has improved over the years so much that, alone, they can handle most needs in close-up shooting. However, one optical fact of close-up life has limited macro shooting until recently: the very limited depth of field at these scales. It's by no means always a problem, and selective focus can produce beautiful effects, particularly in abstract details, but it's been unavoidable until fairly recent developments in digital image processing. The small revolution of focus stacking has enabled a multi-shot technique in which either the camera is racked forward or the lens is focus ring is turned during a shooting sequence of many frames.

Below: The polished inner shell of an abalone takes on a dimensionless appearance in extreme close-up.

Above: Getting so close to a butterfly wing that the texture appears as if it a finely woven fabric is an example of how unexpected details become the main interest in close-up photography.

Style in photography, as in any art form, is extremely tricky to pin down. It's real enough in that the work of well-known photographers is distinctive and recognizable, but describing it calls for the kind of analysis that even the photographer who took the shot might not recognize. While it's immediately obvious to anyone that there are many different styles in photography, there isn't a universally agreed-upon roster. Here, I've assembled styles on a scale that's based on a combination of the photographers' intentions and audience reaction, from low impact to high impact. For simplicity, I call these two ends of the scale Quiet and Dramatic, and while probably no photographer would describe themselves in either of these two words, they're a reasonable description of both aim and effect. Not only that, but they balance each other well on either side of a central basic style—Straight—which acts as a kind of fulcrum.

The practical point, however, is how do we develop our own style. The following pages show the range of other, established photographers' styles, and they're all different from each other. Copying or simply following any of these won't get you any further than being a good imitator. Finding your own distinctive place somewhere within them will, however. The key is knowing what your own strengths and your own ideas are. Ernst Haas said, "Style has no formula but it has a secret key. It is the extension of your own personality." Now you could take this as vague and aloof, but practically it means seeing in your own way, following your own personal interests, and not being in awe of anyone else's work, however much you may admire it.

4

STYLE

ASTONISH ME

Alexey Brodovitch, the Russian-born photographer and designer who became art director of Harper's Bazaar for more than 20 years, was hugely influential on a generation of photographers in America, not just because he commissioned work, but because he was brutally direct.

It's easy to hedge bets when giving advice about photography, or any art, because it's more polite and it lets people off the hook, but that wasn't Brodovitch's style. "Astonish me" was his distillation because he understood photography's special need to be constantly surprising its audience. Only photography in the creative world has this special need, and urgently, because of sheer volume. Photographs are made and consumed rapidly and in huge quantities. They're actually too easy to make, allowing them to become completely familiar. Even

in Brodovitch's time, a half century ago, this was happening. He said, "The public is being spoiled by good technical quality photographs in magazines, on television, in the movies, and they have become bored. The disease of our age is this boredom and a good photographer must successfully

Below: One of photography's goals is to show the audience the unfamiliar, ideally blending striking subject (here salt pans in Tibet along the Mekong River) with distinctive treatment (lighting, composition, and moment).

combat it. The only way to do this is by invention, by surprise."

If there's a fault, it's that of the media that display photographs, and of the sheer simplicity of creation. The New York photographer Art Kane wrote, "[Brodovitch] taught me to be intolerant of mediocrity. He taught me to worship the unknown." Like it or not, photography is consumed in a way that no other art form is, and creative photography gets mixed up with every other kind. So, what might otherwise seem like rather superficial advice—be surprising— is essential. Just listen to or read what professional picture editors and competition judges have to say. This reality is at the top of their list. Fashion photographer Hiro wrote of Brodovitch, "I learned from him that if, when you look in your camera, you see an image you have ever seen before,

Above: Street photography at a high level is idiosyncratic, about seeing and capturing the unusual or personally observed. Here, all faces are obscured for an instant, save that of the carved face on the fountain.

don't click the shutter." That's not easy to do, and comes only with the confidence that experience brings, but it's important because no one will ever remember an image that looks like others they have seen. Ultimately, if you really want to be successful in photography, you need to be uncompromising.

LAYERING

There are several kinds of layering in photography. It's a flexible concept, although people tend to stick to their own, narrower definitions.

The most literal kind of layering is when there is a nearer translucent layer through which we can see the scene beyond, and one traditional way of doing this is to shoot through some kind of screen, which could be as simple as a window partly covered in condensation, or part of something so close and out of focus that it just overlaps the background as a blur of color. A subset of this is using reflections, such as shooting into a store window to merge the scene within and the reflected buildings and sky.

Then there's the long tradition of combining entirely different images into one, or photomontage. One way to do this is creating double or multiple exposure in-camera, where the lighter parts of the second exposure wipe out the darker areas of the first. Another (which dates back to the nineteenth century when it became a staple of Pictorialism and was also used to create "allegorical" photomontages by Oscar Rejlander and others) is printing two or more negatives together. This technique was later used by artists like Jerry Uelsmann and Duane Michals for more surrealist imagery. In pre-digital days, the skill and unpredictability of doing this kind of compositing successfully added to its appeal, which suffered from the ease of achieving the same results— and more sophisticated results—in Photoshop. Nevertheless, digitally layered images, while commonplace, are widely produced, and although they rarely receive the admiration that their predecessors did, can still occasionally be striking.

Less literal is the idea of layering with no trickery other than to compose with a distinct foreground and background (maybe even a middle ground) that have some relation of meaning to each other— a kind of juxtaposition (see page 108). Then there's layering from a conceptual point of view, quite widely used in the art-critic world and referring to photographs that can be "read" on more than one level for different meanings, such as having a sociological context overlaid on a graphical one. What all these interpretations of layering have in common is that the image has, in some way, more than one thing going on, giving the viewer more to look at and possibly think about.

Layering in Practice

Method	Examples
• shooting through screen-like layer	• Saul Letter
• layers from reflections	• Ernst Haas
• pre-digital combined images	• Oscar Rejland, Jerry Uelsmann
• related foreground & background	
• layers of meaning	

Top: The shadow of one scene, a conversation, is projected unexpectedly on another, a shop window, creating intrigue in the form of a second layer.

Bottom: Old glass panes in a church window reflect distorted versions of a single red London bus in Piccadilly.

STRAIGHT STYLE

One really sound principle in art is that an art form does best what it's uniquely capable of rather than pretending to imitate others. Of course, not everyone agrees with this, which is why every so often you get movements like Photorealist painting in the late 1960s and 1970s and Pictorialism in photography from the late 19th to the early 20th century.

These movements happen because artists regularly want to challenge the status quo, but just as regularly, they also get challenged for being too mannered. Without getting too heavily into art criticism, the core strength of photography is capture—freezing chosen moments from life and the world around us. This is what only photography does, and that's a compelling argument for concentrating on it.

This has plenty to do with style because one persistent photographic style that has lasted a very long time (despite the ins and outs of fashion and experimentation) is simply Straight—no-nonsense, technically competent shooting that is nevertheless sensitive to mood, atmosphere, and the inner qualities of people, places, and things. It's not a bad place to start, because there was indeed a named Straight style invented in 1904 by a photography critic, Sadakichi Hartmann, and championed by Alfred Stieglitz' magazine Camera Work.

Stieglitz had started in favor of the then-popular, hazily romantic Pictorialism, but turned against it on the basic argument that a photograph ought to look like a photograph. He championed photographers like Paul Strand, praising his fresh images: "The work is brutally direct. Devoid of flimflam; devoid of trickery and any 'ism'[.]" Ansel Adams, Edward Weston, and others

on the west coast founded Group $f/64$ in 1932 on the same ideal: photography that was un-manipulated, sharply focused (hence the $f/64$, the smallest aperture on a large camera), with rich tonality and high contrast. In other words, photography that was true to the medium and not trying to be tricky. Effort and skill go into lighting and composition in Straight-style photography but it's always reasonable and understandable, never perverse. Precision and perfectionism come high on the list. The subject is always important and is presented clearly, strongly, and usually attractively so that there's some sense of traditional objectivity. Strand himself wrote, "This means a real respect for the thing in front of [you]... accomplished without tricks of process or manipulation through the use of straight photographic methods."

Above, left: Clean execution is the hallmark of straight photography. In this street shot of a smartly attired Havana couple, every essential detail is neatly caught.

Above, right: Neatness is also evident in this overhead shot, where the photographer has used floor markings to contain the figure of a passerby.

Right: Face-on to a kitchen shelf in a Shaker community in Kentucky, this still-life has a clear and clean formality that suits its austere subject.

QUIET STYLE

With the Straight style as a kind of pivot and central point, other styles head off in two opposite directions. One is toward a consciously (some might say self-consciously) withdrawn, dead-pan style that you could call Quiet, while the other is 180 degrees from that toward edginess and brash excitement, in other words Dramatic.

For Quiet style, there are different flavors, all in some way working quite hard at being restrained. Most use composition to keep things calm, but some concentrate on flat lighting and others on muted colors. What they all have in common is that none of them are crowd pleasers in the traditional sense of generating impact and excitement. There is no "wow factor," and the methods used are designed to slow down and pacify the viewing experience. To photographers trained to grab the viewer's attention, they can seem drab and boring, which is perfectly reasonable. If you take all the styles in contemporary photography, there are bound to be more that each individual dislikes than likes. That's personal taste, and there's no arguing with that.

Compositional techniques in Quiet style start with a retreat from strong angles,

unusual viewpoints, and lenses that are wide or long, stepping back toward a kind of studied ordinariness. The risk is in being taken for a genuinely ordinary, thoughtless snapshot, which is why the work of photographers like William Eggleston and the Dusseldorf school of Andreas Gursky, Thomas Struth, and Thomas Ruff, among others, arouse very different reactions, generally, between the art world and the world of popular photography.

Head-on to a subject, flat, and squared up with an absence of diagonals is another method, as is a loose casualness that looks like careless angles and tilts. The minimalist abstraction is also fruitful technique, ruthlessly reducing the number of elements and recognizable details. Layering by shooting through or over defocused foregrounds or misted windows, like Saul Leiter, is another.

Left: Quiet observation and a quiet color appreciation make a gently satisfying image out of a simple moment.

Above: Quietness in treatment involves squared-up and square, formal and ordered with no diagonals, and to this the photographer has quietly added a historical comment between 1930s Art Deco Shanghai and the modern.

Method
- understated, vernacular
- head-on
- loose & casual
- no obvious single subject
- abstract minimalism
- soft layering

Examples
- Alex Soth, Robert Adams
- Walker Evans (some)
- William Eggleston
- Edward Byrtinsky
- Hiroshi Sugimoto
- Saul Leiter

QUIET COLOR & LIGHT

Apart from composition, or in combination with it, Quiet-style techniques include lighting without drama and color without richness and contrast.

Just as with the Quiet composition techniques just discussed, this tends to go against the grain of what popular photography is all about, and that is exactly the point. Light and color are really inseparable, but one or the other usually has a priority, and for lighting, the Quiet strategy is obvious and simple—flat and shadowless. Reversing the popular advice of going for the raking light of a low sun or the less-usual effects of shafts of light breaking through clouds and reflections bounced off glass skyscrapers, shooting in overcast weather takes all lighting excitement out of the image. As with Quiet composition, it's very much a matter of taste, but also has some logic in that it focuses attention more on the content of the subject and on the simplicity of colors.

As for color methods, the techniques involve making use of flat lighting and choosing color palettes that are muted— all too common in most modern, urban landscape. In fact, one of the most fundamental disagreements in serious color photography in the art world is between rich and muted. It dates back to the early 1970s in America when the curator of MoMA, John Szarkowski, set about overhauling the aesthetics of photography. Among his targets was the "sensationalizing" of color, referring to Kodachrome-inspired richness. This is how the New Color movement started, and its legacy is a style of shooting that aims for restraint rather than, as one writer put it, "producing extravagantly lush, festive hues from less flamboyant sources."

What this means practically is choosing to work with a limited range of hues, and definitely with less-saturated ones. That may sound like a style based on avoidance (of splashes of bright color, mainly, and of painfully blue skies), but dealing with it positively really means searching out scenes and subjects where the colors are closer together and you're exploring subtle variations. Diffuse light usually helps, as does any slight thickening of the atmosphere, such as a little mistiness or pouring rain. Of course, to take this seriously you would have to agree with Szarkowski saying "[m]ost color photography, in short, has been either formless or pretty."

Above: Soft, unsaturated colors under a cloudy sky support the delicacy of the pink flowers on a South American savannah.

Method
- flat natural light
- flat studio light
- muted color
- low-contrast monotone

Examples
- Andreas Gursky
- Thomas Ruff
- Joel Sternfeld
- Bernd & Hilla Becher

DRAMATIC STYLE

It's hardly a surprise that this is the biggest of my three groups. Straight is by definition straightforward, and there are a limited number of ways of being in the Quiet category while still bringing specific character to an image.

Exaggeration in every area of life has a bigger canvas than restraint, and photography is no exception. Without trying to reduce the variety of ways in which photographers create drama in composing images to a single element, diagonals usually play a key role, whether they sweep together across a frame, intersect in multiple angles, or enclose wedges and triangles of contrasting colors or light.

In composition, angular and geometric is one of the most-used ways of bringing attention to the image and imposing the photographer's will on the scene. A potentially angular subject makes a good start, but hard lighting can create angular shapes via shadows and strong chiaroscuro. In either case, drama usually means going for some kind of abstraction, treating the parts of a scene rather more as shapes than as physical subjects. One obvious way of encouraging diagonals in an image is to tilt the camera, which is natural to do by aiming up or down, but rather less so by rolling the camera, which is more eye-catching but also less acceptable to many people.

Ground zero for conventional composition is a horizontal horizon, or anything that stands in for it, like street level. Depart from this and it tends to look like a mistake (and in fact, most of the time probably is), but if you set aside the need to keep level things

Below: Extreme and yet simple is the compositional style in this shot in Havana. Placing the woman's head in a corner places more emphasis on the color of the wall..

Method	Examples
• angular, geometric	• Guy Bourdin
• tilted camera	• Garry Winogrand
• eccentric placement	• Guy Bourdin
• engineered disorder	• Alex Webb
• unexpected juxtaposition	• Richard Kalvar
• energetic layering	• Ernst Haas
• energetic abstraction	
• Impressionistic	• Laura Al Tantawy

204

level, any lines in the scene are fair game for making parallel to any of the sides of the frame. American street photographer Garry Winogrand was known for this, and one or twice explained that he was always lining something up with a frame edge, just not necessarily the horizon. When Robert Frank published his at-the-time controversial book The Americans, the scathing review in the magazine Popular Photography derided his "drunken horizons and general sloppiness."

However, in all ways of shooting, Dramatic as an idea calls for some kind of challenge to what the audience expects. Yes, so do the extremes of Quiet style, but Dramatic does it with a direct, immediate punch. Where you place the key subject can also have this effect, and highly eccentric placement, such as in one corner, is one distinct technique. It also runs the risk, though, of looking perverse, so it's good to have some reason for doing this. One effect of eccentric placement is to draw attention to the rest of the setting and set up more of a relationship between the small, off-center subject and the large background.

Above: Part of the dramatic repertoire is handling complex, subject-rich scenes by splitting them into distinct parts with strong light and shade

Another dramatic technique that calls for considerable skill is a kind of engineered disorder in which the scene is complicated with several competing visual "units" vying for attention, some of them usually breaking the frame. To work, this kind of high-energy composition needs each of the elements to fit together in the frame and stay mainly separated. Part of the appeal of this is simply the photographer's skill at fitting the pieces of the jigsaw together, inevitably plus luck. Putting visual pieces together is also the key to the kind of juxtaposition that the viewer could never expect. We saw juxtaposition at work in "Coincidence and Coinciding" on page 108; finding really clever and unusual juxtapositions simply works more dramatically and is, incidentally, the key technique in comedic street photography.

In the opposite direction, away from relationships between subjects that suggest some new meaning, drama can also make use of abstraction, deliberately confusing the viewer about what exactly is being photographed, and whenever possible turning subjects into shapes. Layering is one method, particularly using reflections, but the effect is altogether stronger than the quiet layering we saw earlier that Saul Leiter made a specialty of.

Above: In this aerial view, the dark earth is the background for two contrasting units—a cluster of Islamic tombs and, seen after a short delay, the small, eccentrically placed figure of a man.

Dramatic Lighting

Lighting can also contribute to drama, and doing this almost always means high contrast in one form or another. Whether from natural light or in the studio, strong, sharp, spot-lit effects with hard-edged shadows, particularly when small parts of the image are illuminated out of a dark setting, are generally guaranteed to inject a sense of the theatrical. Stark sunlight, bare bulb lamps and focusing spots are sources with dramatic potential. Chiaroscuro, silhouettes, high key, and low key (pages 138–139) are the typical lighting forms.

Above: Chiaroscuro is the strong interplay of light and shade, here in a Sudanese market coming from shafts of sunlight striking directly and bouncing off a green surface.

Opposite: Hard-edged shadows, particularly wrapped around repeating patterns like this, beg for a high-contrast black-and-white treatment.

Method	Examples
• dramatic, theatrical	• Trent Parke
• chiaroscuro	• Gueorgui Pinkhassov
• high key	
• low key	
• multiple source	• George Hurrel
• spot-lit	
• bare bulb	• Irving Penn (some)
• flared backlit	
• silhouette	

Dramatic Color

Color, too, lends itself to being used to enhance and excite when the saturation is high and strongly contrasting hues are combined in the same frame. As we saw on pages 144–145, colors are seen as being harmonious or discordant according to their positions around the color wheel. Discordant colors—clashing, garish—have extra dramatic potential. Monochrome can also be treated as a kind of color, and is at its most dramatic when processed for maximum contrast between rich blacks and luminous whites.

Method	Examples
• rich, saturated	
• strong contrast	
• color accent	
• garish	
• hard black & white	• Bill Brandt (later)

Opposite: Strongly saturated contrasting colors combine with hard lighting in a lane in a village on the island of La Réunion.

Below: Spot color, aka color accent, also achieves a dramatic effect by its isolation and contrast with the remainder of the scene, here in a river in China.

Dramatic Optics

Finally, the extremes of lens design (see pages 48–53) offer an essentially optical route toward drama, notably very long telephotos that compress planes and very wide-angle lenses with their geometric distortion (at its greatest with fish-eyes). Both of these extremes give views that are far from what we're accustomed to seeing with our own eyes. Other optical effects that rely on being different from how we perceive, and which can also be used dramatically, are strongly out-of-focus areas and motion blur. Whether from the lens or the shutter speed, all these optical effects are basically about adding an insistent layer to the photograph that reminds the viewer about the camera and its processes.

Method
- wide-angle distorted
- wide-angle immersive
- telephoto compressed
- deep focus
- selective focus
- defocused
- panoramic
- motion blur

Opposite: Controled slow shutter speed introduces motion blur, in this instance of a whirling Sufi dancer in Omdurman, Sudan—sufficient to enhance the movement while remaining perfectly readable.

Below: Wide-angle lenses used from very low and close create strong convergence—here a 20mm lens at a church in Santa Fe.

There was a time when a photograph basically meant a print that you handed to someone or, if it were important enough, one that hung on a gallery wall. A sub-variety was the printed page, meaning offset printing in a magazine or a book, but that was exclusively for professionals. That's all changed, not only because photography is much more democratic, but because the so-called platforms have multiplied. The Canadian communications guru of the 1960s, Marshall McLuhan, claimed that "the medium is the message"—a phrase that was famously confusing at the time but is now obvious.

The media in which you show your images transform them. Seeing them as a print, on a gallery wall, in a slideshow, on your iPhone, through an app, and so on doesn't just color the experience of viewing your pictures, it creates a whole new work. Showing your images is, or ought to be, an experience in its own right. It deserves different skills from the taking of photographs. It's organizational and technical, certainly, but at its best it's also artistic. Not every photographer is interested in showing, but you might want to think about what your hard-won images deserve. You've already taken them, and some of them you love, but there's a world of difference between just throwing them at a sharing website and crafting the viewing experience... not the least of which is that you'll almost always be showing several to many images together as a group.

On the following pages I'll introduce you to the skills of picture editing (and there are many) for selecting which images go together with which, and the sometimes-powerful effects this can have on your audience. Even though these skills were developed a long time ago—beginning in the 1930s with the birth of the picture magazines that relied on photography and indeed helped create photo-reportage—they run deeper than any specific media. There will always be new media coming up, and they'll demand extra skills, but this is the core.

5

SHOW

BODY OF WORK

While the shot of the moment is the only thing that counts at the time, ultimately we're all building up a collection of images, one by one, that will define who we are as photographers.

Call it a portfolio if you like; the body of work is the permanent record of the best and most distinctive photographs we've taken. It can be for your own satisfaction, to share among friends, or you can use it commercially as your sales pitch, but it doesn't happen just by itself. It needs nurturing and planning for. There are two good reasons why you should take charge of this collection. One is that you should only ever show the very best of what you shoot. Anything else diminishes your body of work. The second is that, as most of us shoot quite a variety of kinds of images, the body of work that you select needs to be directed so that you're presenting exactly the side of your work that you want to promote. It's a little like brand management, and the brand is you.

Building a body of work involves thinking clearly about your style as it evolves and making sure that what you show to others fits this. Russian photographer Gueorgui Pinkhassov says, "I really take a lot of photographs, but I only show the ones that suddenly speak to me, that come alive when I look at them." After a day's shoot, for example, it's entirely natural to want to have taken at least one good image, but in the cold light of next week or next month, that best-of-the-day shot may lose some of

its luster. It's crucial to select strictly the best for your body of work. Go easy on yourself and you'll only dilute your overall impression on the audience.

Take into account how this collection of images will be displayed. By far the most common way is on a website—your own, not a shared site—as we'll see on pages 228. If you use a site to sell images or show specific projects, consider separating out the very best from the rest. Attention spans are short on the internet.

Opposite: Photographers' personal websites are increasingly the platform for displaying their body of work, meaning the first-glance, tightly edited collection of images that they believe represent the best of what they've done. Given modern short attention spans, less is usually more, and repetition to be avoided.

SEARCH

SEARCH

215

GALLERIES | CONTACT/SALES | BLOG |
BOOK STORE | WORKSHOPS & COURSES |

Michael
Freeman
PHOTOGRAPHY

WEBSITE & SLIDESHOW

For any photographer, the prime location for showing work is their website, and yours deserves your full attention in designing it. This is where you present yourself—a bio, contact details, your best work—and possibly sell images.

This is most photographers' main marketing tool, so the sensible approach is first to decide clearly what aspect of yourself and your photography you are selling and to whom. Are you trying to impress potential clients and get assignments or sell existing images from your stock library? How do you want to be thought of? Photography is a highly competitive world, whether for art or business, so do you know who your close competition is? Assuming you do, are you presenting yourself in an effectively competitive way? Being effective often means not appearing to compete. All of these marketing decisions need to be sorted out before you move on to the design and functionality of your site.

At the core of an effective photography website is the slideshow, and there are likely to be several. This is the single most important vehicle for showing photos—a sequence on screen of uncluttered images displayed large; everything else is simply navigation.

Look at any major site that displays photography, such as LensCulture, Time Lightbox, and National Geographic. Within one click, you will be presented with a slideshow of several images. Moreover, despite the endless possibilities for design and functionality, professionally designed slideshows are always simple. Complication and elaboration only detract from the imagery, and all that's really needed is an obvious way of moving from one image to the next, and the option of reading captions and possibly an introduction. The standard functionality is a click through, with arrows left and right of the image so that the viewer can choose the viewing speed, but there is also an argument for a website to open with an automated slideshow so that by default, without the viewer being asked to do anything, your best images appear in sequence.

Below: One tried and tested on-screen presentation method is a slideshow—images shown one at a time, in sequence. First, this allows images to be displayed large, up to full screen, while second, the sequencing promotes variety. Time on screen and transitions are important considerations

© Michael Freeman 16 of 20

Slideshow Transitions

Cut: the simplest of all; an abrupt replacement of one image by the next

Dissolve or cross-fade: one image blends directly into the next, choose the speed; fast is half a second or less, slow is several seconds; slow dissolves announce a relationship between two images

Fade to black or white: a two-stage dissolve in which one image dissolves to black or white then into the next image

Fade in / fade out: at the beginning or end of a slideshow, the image fades to the background color

Wipe: generally right to left, one image replaces another moving across the screen

Push: another cross-screen movement; the next image appears to push the first off the screen

Pan & zoom: animates still images by zooming in or out; useful with widescreen or panoramic formats; also effective if almost imperceptibly slow

THE ART OF SELECTING

In photography now, we do almost everything ourselves, individually, from processing to posting on the Internet. That's liberating, but one of the skills that's in danger of getting lost is the cool, professional eye of an experienced picture editor.

Few of us are trained to look at a take (a word also in danger of disappearing) with an objective eye while also knowing how to find the best few images out of many. This is what the art of selecting is about, and it comes in two flavors: the Photographers' Edit and the Editor's Edit. You have to be able to do both for yourself.

The Photographer's Edit is, or ought to be, part of the seamless process of shooting through to final best image. When you shoot several images of a single scene or an extended moment, you're almost always shooting to achieve one best image out of the sequence. When shooting, you ought to be anticipating which of these is going to be the one, thinking ahead to the edit, possibly even without realizing it. There are different techniques for doing this, but I suggest a two-handed approach. The first way is to "relive" the shoot, remembering which you thought at the time were the best shots and why you were shooting them. This works well when you shoot blocks of frames aiming for just one (see "Moment" on page 120). The second way is to objectify. Come back to it later and distance yourself from the heat of the shooting. Take a longer, cooler look, and resist the temptation to automatically love what you shot. Be your own critic.

The Editor's Edit means wearing a totally different cap, as if you had been shooting to a brief, with all ego stripped away. The important thing here is to distance yourself from the shooting and take on the different persona of a designer—a more editorial point of view. This takes more imagination and less kindness. Be your own client and judge your images on how they are going to be used, not how wonderfully (according to you) you shot them. The real issue is sequencing the images (making them work together), and it's more difficult for a photographer because we usually weren't thinking like that during shooting. If you have a project, you can actually try this, and it's the standard technique on long editorial assignments; shoot towards final assembly.

Opposite, top: Within any shoot, there are likely to be "blocks," where you're shooting many in order to achieve a single best. One of the first steps in selection is to reduce these groups to a single best image, before continuing to evaluate it against others

Opposite, below: This shoot in a wet market lasted 27 minutes and produced 86 frames. The layout here shows the time sequence, "blocks" (outlined in yellow), change of lens from mid-range zoom to wide-angle zoom, changes of ISO, and selects (green dots).

219

SEQUENCING

Most photographs are seen in the company of others, and this creates a very particular environment for viewing. Even though you may shoot one image at a time, with no thought of the next, your audience will almost always be looking at a sequence (as long as they stay interested, that is).

It doesn't matter whether it's a photo essay telling a single story, a typology of similar images, a slideshow on a website, or a collection of prints on a gallery wall, they are probably going to be seen in a predictable order. This is an extension of the art of picture editing, and the skill lies in finding a way to sequence the photographs so that they seem to flow naturally from one to another and have some connection.

The most solid way of doing this is through narrative, as we'll see that on the

following pages. This depends on having a
distinct story to tell. Story is a fashionable
buzzword, but well overused. More often,
there's simply a collection of images that
are gathered around a subject or a style.
Even so, sequencing at its best means
selecting the order of viewing so that there's
rhythm and pacing, varying the intensity of
different image qualities to keep the viewer
interested in continuing to follow the series
of pictures. This does not mean sprinkling
better images among less-good ones (every
image has to be strong or it's not worth
showing), but rather moving, for example,
from small scale to large scale, from colorful
to muted, and so on. It means finding a
workable balance between continuity and
variety so that a sequence looks like it
comes from the same place (your camera
and your eye) yet has a changing visual
rhythm.

Below: One method of sequencing,
here applied to a photo book laid out
with facing images on a spread in a
traditional layout, uses the domino
principle. In the game, the tiles are
placed in a line, with the number of
spots at one end matching the next tile.
Applied to sequencing images in order
to change from one set to another, the
ideal is to find one image that bridges
the gap (in some visual way) between
sets of images—finding a connection.
It could be in the subject, color, shape,
positioning, or indeed any matching
graphic quality.

PAIRING & THE THIRD EFFECT

The short form of a sequence of photographs is a simple pairing, one image next to another, and one of the reasons this is so common is that in a book, the viewing unit is a two-page spread.

With one image per page, the two facing photographs automatically relate to each other. In exactly the same way that you can use juxtaposition in a single image to make a connection that other people might not reach; you can pair two finished images to point out connections between them. The connection might be visual and graphic or perhaps in meaning, suggesting some kind of comparison. This is a kind of suggestive storytelling. Wilson Hicks, the picture editor of Life magazine in its heyday from 1937 to 1950, coined the term "The Third Effect" to describe the extra, unexpected meaning that can happen when you put two seemingly unrelated photographs together. He wrote, "their individual effects are combined and enhanced by the readers' interpretative and evaluative reaction," meaning that the viewer picks up on any coincidences or correspondences and begins to think more about the two images and their relationship.

The pairings here are from a book on the life of a South American city, Cartagena, Colombia. As the book's basic design is one image per page, all of the pairings deserve some thought.

Opposite: Three pairs with links that include content and graphics. Top: contrasting hairdressing situations with some irony. Center: food, two women, red chairs. Bottom: shaved-ice grinders medium and close, with one color linkage.

NARRATIVE

One of the most newly overused words in editorial photography is storytelling, and with it the idea that every picture can and should tell a story. It's a nice conceit, and the idea of reportage photographs being rich, full of incident, and suggestive is good, but real storytelling has to use narrative.

Narrative takes time to tell and to absorb. The picture story, or photo essay, has a deep tradition than goes hand in hand with the era of the picture magazine, which began in Germany in the 1930s and blossomed in the 1940s and 1950s with Life, Look and National Geographic in the US, Picture Post in the UK, Paris Match in France and Epoca in Italy. Others like GEO and the weekend newspaper supplements followed. Few are left, and the media have largely moved on to screen-based, web-based slideshows and galleries, but the legacy of a set of photographs that genuinely tell an engaging story is fully alive and well.

In one way, photographic narrative bridges the gap between shooting and showing because the best stories are always conceived from the start by the photographer who executes them, yet to be effective they depend entirely on being presented as a sequence to an audience in a certain order. Increasingly, photo competitions—platforms for emerging photographers that have never been as popular as they are now—have categories for picture stories. Narrative is on trend.

Successful narrative, in photographs as in words or movies, demands structure, and it's no coincidence that the idea of a script is common to all. The picture script (essentially an educated wish list) is the plan for any story; if the images are going to flow seamlessly on the screen and in the viewer's mind, they get a tremendous boost from being anticipated. As always, the very best images resist being predicted and need luck, but that doesn't prevent you from imagining how the ideal flow would work.

Opposite: The opening double-page spread of a story on falconry laid out for print. The 10-page story continues overleaf. Print stories offer the possibility of designing spatially (the individual spread) and sequentially (as the pages are turned).

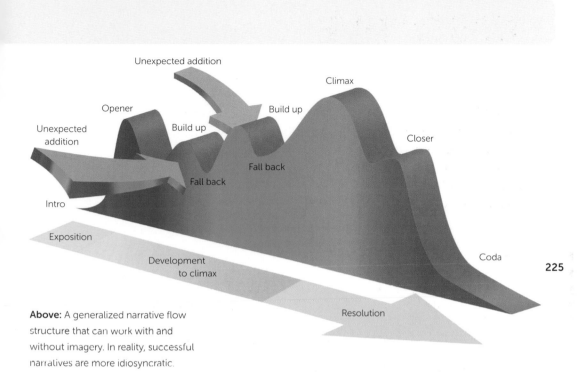

Unexpected addition

Climax

Opener

Build up

Unexpected
addition

Build up

Closer

Intro

Fall back

Fall back

Exposition

Development
to climax

Coda

Resolution

Above: A generalized narrative flow
structure that can work with and
without imagery. In reality, successful
narratives are more idiosyncratic.

A<small>RT</small>
OF THE
KILL

Lorem ipsum dolor sit amet,
consectetur adipiscing elit.
Sed id felis non eros tristique
euismod vitae ac dolor. Cur
abitur at pellentesque metus.
Cras at leo ac nibh rhoncus
tincidunt. Ut vel sem tellus.
Curabitur nec orci risus, ut
gravida turpis. Aliquam a
erat justo, quis varius mag
Proin hendrerit adipiscing
eros, at gravida nulla venen
atis sit amet. Aenean sollici
tudin convallis semper.
Curabitur augue velit, eges
tas id luctus vitae, interdum
in est. Nam quis hendrerit

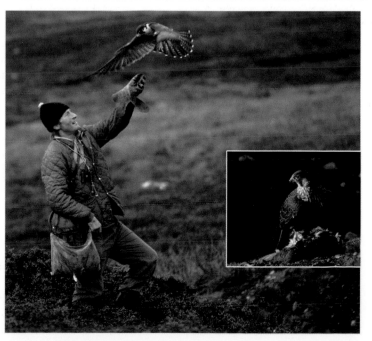

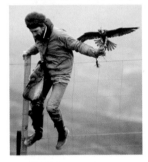

A longer caption to cover all the pictures in this layout, showing the role of the dogs—pointers, who first alert the falconers to the presence of grouse, and then take up positions ready to charge forward.

The caption copy goes here under one side of the photograph, but no more than three or four lines in this layout.

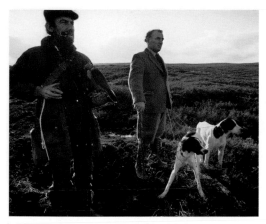

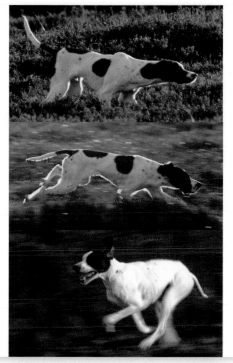

Lorem ipsum dolor sit amet, consectetur adipiscing elit. Fusce vestibulum, erat in tempus ullamcorper, libero metus pretium magna, acultrices neque nisl nec sem. Cras id ante in augue adipiscing faucibus dignissim a nisl. Duis tincidunt semper turpis id interdum. Nullam sollicitudin venenatis faucibus. Vestibulum at velit libero, ut interdum libero. In hac habitasse platea dictumst. Curabitur in lacinia metus. Cras mollis erat in metus blandit consectetur. Quisque id erat in sem rutrum fringilla sollicitudin non enim. Donec volutpat ultrices quam, eu facilisis ante scelerisque eu. Cur bitur ultricies gravida ante, vel blandit diam placerat quis. Quisque vestibulum consectetur elit et molestie. Duis tincidunt semper turpis id interdum. Nullam sollicitudin venenatis faucibus. Vestibulum at velit libero, ut interdum libero. In hac habitasse platea dictumst.

The real action begins when the dogs (pointers) are called to rush forward to set the grouse up.

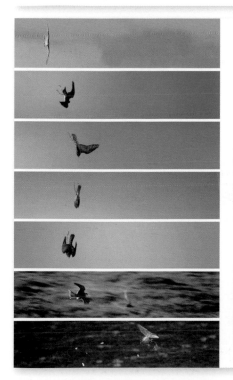

And a longer two-line caption looks like this, sufficient to run under a single large photograph.

SOCIAL MEDIA

Love it or hate it, social media has firmly established itself as a key part of a photographer's life. And so it should, as this eminently visual media is a natural fit.

Too many photographers use their social-media outlets purely as an exercise is self-promotion. Pushing your brand and, of course, your photography is a perfectly valid use of the platform, sure, but the best way to do so successfully is to engage with other photographers as well. A dialog is, for one, interesting in its own right, and viewing other photographer's work is always a valuable exercise, particularly when you can easily ask them a specific question should you have one. Make a point to spend some time liking, retweeting, and commenting—it catches other photographer's attention, which then in turn leads them back to your platform, and so on and so on.

The other key is to keep your platform active. Going on one trip, uploading 50 images all at once, only to let the account lie fallow for months until you regain interest, isn't a useful exercise. You'll lose both your followers and your own interest. It helps not to be a perfectionist about every shot. That's not to say you shouldn't take your edits seriously, but embracing the casual can, at least from time to time, help keep up your momentum.

@michaelhfreeman Tweets Tweets & replies Media

Follow

Above: Twitter remains one of the most important social networking service (apart from in China). It's ease of sharing imagery makes it useful for photographers looking to gain an audience outside formally published media.

Michaelfreemanphotography

Following ▼ ...|

Michael Freeman is an award-winning editorial photographer and the world's top author of books on photography. www.michaelfreemanphoto.com

Above: Instagram, which can be integrated in use with Facebook, is entirely image-based, and for a growing number of photographers who use social media is becoming the top priority.

BOOKS

There is now much more flexibility and opportunity to publish your own photography book than ever before.

Digital book production is now a wide choice of paper, binding, and format and is ideal for small print runs, while the economics of even traditional offset printing have become more accommodating. Perhaps the most significant recent change, though, has been the explosion of interest in photo books, ranging from the coffee-table books offered by large established publishing houses to handmade artists' editions. These are now recognized by photo book awards, publishing grants, and institutions and they are highly collectible. Competitions such as the annual Paris Photo-Aperture Foundation Award function as a survey of the best, as does The PhotoBook Review, published twice yearly by Aperture.

In the established publishing world, large houses like Thames and Hudson, Phaidon, Taschen, and teNeues have photography lists and the capacity to produce large coffee-table editions with respectable print runs. Then there is a diverse group of publishers who focus on photo books that have no aim other than to present a collection of photographs in the form of a unique object, and they range from the established like Steidl and Aperture to newer and smaller publishers like Mack, Dewi Lewis, Radius, and Damiani. Fastest growing of all are independently produced books by the photographers themselves, taking advantage of digital printing but also, at the far end of artisanship, self-made books. Curator Yumi Goto with her Reminders Project in Tokyo teaches total photo-book creation in annual workshops.

Above: A small-run, high-production-value photobook, with emphasis placed on paper material and on distinctive design. Photobooks are their own integrated work rather than just a vehicle for displaying a number of images.

6

RESOURCES

Resources

The huge surge of interest and participation in photography over the last decade internationally means that there is no shortage of resources to help you, from the technical to the aspirational.

These resources basically split into information, teaching, exhibition and association, as I'll explain below. The media has also broadened hugely, which gives us all more choice, but also less certainty. Print publishing, both books and magazines, remains core. One reason is control over picture quality, another that it's often faster to flick through a book and find what you want than scroll through on-screen pages, and a third the physical, tactile pleasure of handling books. Also worth bearing in mind is that print publishing is costly and needs organisation, so you can be fairly confident that what you're reading is accurate and worthwhile (it's a competitive market). This isn't true of the internet. The wider on-line world is now plagued by fake news, and the photographic equivalent is inaccuracy, misinformation and uninformed opinion. Unless the website you're looking at is from a known and trusted organisation, treat its contents with caution, and double-check elsewhere if you're searching for hard information.

Information

Books like this are a basic source of trustworthy information (well, he would say that, wouldn't he), as are magazines like N Photo, Amateur Photographer and Photo District News (which have on-line presence also). On-line, DPReview is the established camera review site, while quality manufacturers like Manfrotto, Zeiss, Nikon, Canon and Sony, all have technical information sections.

Teaching

Skipping over full-time university and college courses, there are many on-line study-as-you-please courses. The problem is reputation, because anyone can set one up and give it a convincing name (photography isn't exactly the medical profession). Look for accreditation and for student reviews, as well as checking who exactly the tutors are. MyPhotoSchool from learningwithexperts. com is one of a number of reputable online courses. Other possibilities for teaching are workshops and private mentoring. In both cases, research the individual photographer offering them—does he or she have a reputation, and are there good reviews?

Associations

There are forums, groupings and formal associations to suit every taste, and being a member of a like-minded group of photographers allows you to exchange ideas and information, and often to comment on each others' work (which may or may not be a good idea). 500px and Fstoppers are two popular communities with a reasonable standard. For professionals, communities such as EPUK concentrate solely on business matters, not aesthetic.

Exhibition

BookGetting your work seen widely by others is a basic goal for most photographers, and there are platforms for this. At the same time, I can't stress too strongly how important it is to keep looking at other people's work across a range of photographic subjects, themes and styles. It will help you form your own opinions, and give you a sense of what's going on in the photographic world. The big issue, however, is who does the curating. In the physical world, major museums like the Tate Modern in London and MoMA in New York are totally reliable, as are galleries with established reputations like the Photographer's Gallery in London. On-line, LensCulture has firmly established itself as a site thet shows the best and most interesting of contemporary photography— and it invites entries from everyone. Some newspapers have solid photography sections on-line, notably the Guardian, New York Times and Washington Post. Beyond this, photo competitions can have a wide reach and also offer prizes, but beware that many are unfortunately just cynical ways of collecting your entry fee. Sites like photo competitions.com show what's available at a reputable level

Index

distort 176, 179
DNG 15, 26
DNG Profile Editor 26
dramatic style 174, 202–211
Drobo 79, 83
DSLRs 28–29, 52, 76, 102, 122
Dusseldorf school 198
DXO Optics Pro 80, 84
dynamic range 12, 16–17, 20–21, 84–85, 92,
 94–97, 132

E

Eggleston, William 198
electronic viewfinder (EVF) 30, 34
Erwitt, Elliott 46
Evans, Walker 48
EVF 34
exposure compensation 24
exposure triangle 19
extension rings 52
eyelines 106

F

fast lens 57, 182
field cameras 37
file naming 82
fill flash 64
firmware 12
flagging 72
flash 61–67, 120, 186
fluorescent lamps 67
focal length 28, 42–53, 57, 63, 108, 112–113,
 118, 144
focus blur 57
focus stacking 58–59, 188
fog 130–131
found-object still life 182
framing 24, 43, 46, 49, 59, 102–103, 111, 120,
 141, 144
Frank, Robert 204
Fresnels 70, 73

G

Gamma 15
Gehry, Frank 174
Gilden, Bruce 159

goalpost arrangement 75
gobos 72
Goethe, J.W. von 98, 144
Golden Hour 126–127, 130
Golden, Robert 184
Golden Section 144
GoPro 186
gravity 119, 174
Group ƒ/64 196
Gursky, Andreas 169, 198

H

Haas, Ernst 48, 118, 140, 190
hard drives 78
hardware 78
Hartmann, Sadakichi 196
Hasselblad 32, 37
Havana, Cuba 39, 173, 197, 203
HDR 58, 59, 94–97, 132–133, 154, 179–182
Heatherwick, Thomas 176
Hicks, Wilson 222
high ISO 19, 51
high key 20, 23, 138, 154, 207
HMI lamps 67, 69
horizons 55, 60, 126, 131, 152, 168, 170–171,
 202, 204
Horseman 32
hyperfocal distance 55

I

image quality 12, 18, 19, 30, 32, 37, 38
image storage 2, 14, 78, 79, 82, 83
indoors 58
ingredients of a photograph 100
interiors 44, 62, 76, 132, 178, 179, 180
IPTC Metadata 80
ISO 18, 19, 38, 40, 41, 58, 65, 66, 89, 134,
 164, 218

J

JPEG 15, 16, 17
juxtaposition 108, 194, 203, 204, 222

THE PHOTOGRAPHER'S HANDBOOK

Picture Credits